POSTCARD HISTORY SERIES

Chattanooga

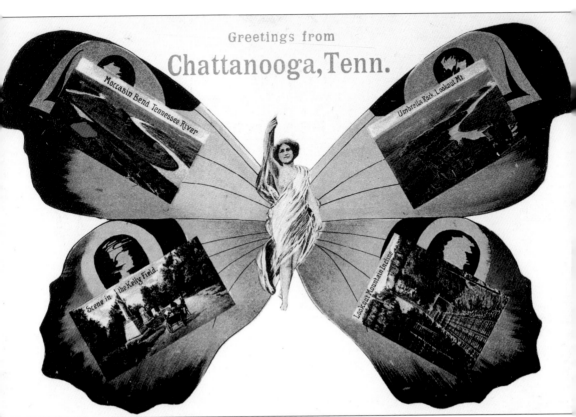

Greetings from
Chattanooga, Tenn.

Moccasin Bend Tennessee River

Umbrella Rock, Lookout Mt.

Scene in the Kelly Field.

Lookout Mountain Incline

GREETINGS FROM CHATTANOOGA. The "Greetings from . . ." type of postcard with the butterfly design is relatively scarce and much desired by collectors. Published *c.* 1905 by Raphael Tuck and Sons of London, the series uses a number of different cities' names, with small views superimposed on the butterfly wings. The Chattanooga scenes included are as follows: Moccasin Bend, Umbrella Rock, the Lookout Mountain Incline, and a scene in Kelly Field.

POSTCARD HISTORY SERIES

Chattanooga

Elena Irish Zimmerman

ARCADIA

Published by Arcadia Publishing
Charleston SC, Chicago IL, Portsmouth NH, San Francisco CA

Printed in the United States of America

Library of Congress Catalog Card Number: 98-86899

For all general information contact Arcadia Publishing at:
Telephone 843-853-2070
Fax 843-853-0044
E-Mail sales@arcadiapublishing.com

For customer service and orders:
Toll-Free 1-888-313-2665

Visit us on the internet at http://www.arcadiapublishing.com

This book is for Paul and Karl, who remember Chattanooga.

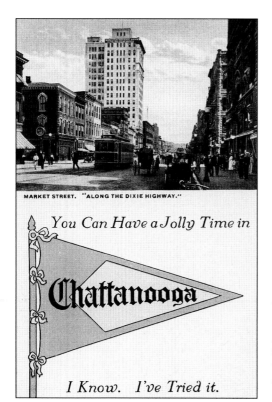

YOU CAN HAVE A JOLLY TIME IN CHATTANOOGA. Many postcards heralded a given city as "a jolly place to be." This card shows an early Market Street scene (*c.* 1912) with a horse and carriage, trolley, and automobile indicative of the times. (Published by T.H. Payne, Chattanooga.)

4

CONTENTS

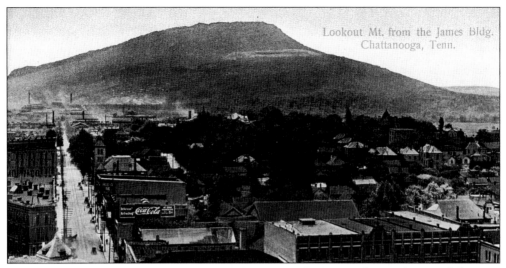

LOOKOUT MOUNTAIN FROM THE JAMES BUILDING. Rising to the southwest of the city, Lookout Mountain is a visible landmark known to everyone. This partial view (*c.* 1910) shows the city nestled in the valley, with tiny carriages on the thoroughfare (left). The Coca-Cola sign shows the current price to be 5¢. (Published by International Post card Company, New York.)

ACKNOWLEDGMENTS

My grateful thanks are due to those good friends who helped me with this book. I especially want to thank Nancy Dobbs for her generous willingness to share cards and information, and I want to express my gratitude to my son, Richard P. Zimmerman, for his ready help with the library research. I appreciate also the interest and enthusiasm of the members of the East Tennessee Postcard Club, especially Betty Curtis and Milton Hinshilwood, whose input, advice, and reactions to my questions were always welcome and helpful. Thanks to you all.

—Elena Irish Zimmerman
June 1998

INTRODUCTION

The pictures in this book are reprints of postcards that were manufactured and sent through the mail in the United States between 1900 and 1940. Each one represents a moment of frozen time—life as it was on a certain day in a certain year—even more than the usual photographer's studio picture. Here is a street, a building, or an event caught in an image printed on a 3-1/2-by-5-5/8-inch card, sent from one person to another to communicate something of importance to both of them. Because postcards are used in this way, they have become memorabilia not only of personal history but of the geographical, architectural, patriotic, religious, and artistic history of the communities from which they originate. All of these aspects of life may be enjoyed and studied in postcard pictures.

Chattanooga is pictured in this selection of over 200 postcard images. The city and its accomplishments are revealed, not only by pictured buildings and events, but also by the personalities of the senders and recipients. Shown here are the scenic beauties of the environs, the public buildings and various businesses, homes, churches, and schools; the activity in the streets as it was in the early days of the century; the Civil War history so rich in this area; and the views and development of Lookout Mountain and Signal Mountain. Also included are many "signatures" of Chattanooga—Moccasin Bend, Umbrella Rock, Missionary Ridge, magnificent monuments, and many more.

To organize and present these postcard images has been a privilege and a pleasure. The author has collected vintage postcards on many subjects for nearly 30 years, through attendance at antique shows and flea markets, and by auction bidding. Organizing this group of 200 cards into chapters or sections was a task requiring some historical research, and a bibliography has been provided. There is much to read about Chattanooga's past.

Postcard collecting as a hobby has been popular since 1900 and still has many devotees today. It is the third most popular collecting hobby in the United States, after stamps and coins. The first postcards in this country were printed in 1893 to be distributed at the Columbian Exposition in Chicago. When Congress, in 1898, allowed cards to be mailed for a penny, numerous photographers began producing them and the business has soared ever since. In spite of escalating postage prices, the postcard is still cheaper than a letter—and it provides a picture. The picture has always been a contemporary one; a card mailed in 1910 will show history "as it was" in 1910; a card mailed today will show something of 1998.

People have always seemed interested in collecting the past. Collectors abound who search antique shops and flea markets for everything from beaded purses to miner's hats; from matchbox

covers to satin slippers; from Chippendale chairs to Burmese glass. Postcards may be included here as valuable vintage collectibles, with an advantage—they don't usually cost as much as other collectibles do. It is true, however, that the rarities among postcards are beginning to reach high prices in the antique market.

Almost everything in the world is pictured on postcards: scenes from most of the cities of the world; animals and birds; babies and children; beautiful women; famous people; war scenes (pick your war); Christmas, Easter, and all other holiday greetings; comics and cartoons; sports; parades; and so many others. Collecting postcards of any era one chooses—some worthy of being called art—is varied and exciting. When collectors get together, usually at one of the many postcard clubs that exist in the United States, they have much to "show and tell" each other.

When a postcard collector acquires a large number of cards on a specific subject, these cards form an ongoing illustration of history. The cards included in this book form such a group. From the author's collection of several hundred Chattanooga postcards, examples of the very best have been chosen to show the city's historic development between 1900 and 1940.

The author hopes that the reader of this book will enjoy the postal history of Chattanooga thus presented as much as she did in the preparation of it.

A LOOK AT
CHATTANOOGA HISTORY

The name Chattanooga comes from the Creek "Chat-to-to-noog-ge," meaning "rock rising to a point" (a probable description of Lookout Mountain). It lies near the Georgia and Alabama state lines on the sharp Moccasin Bend of the Tennessee River, in a valley surrounded by Missionary Ridge on the east, Signal Mountain on the northwest, and Lookout Mountain on the southwest. The ridges are so steep that tunnels had to be blasted through them to make way for the main highways into the city.

Because of its location, Chattanooga has always been an important junction for river traffic and many lines of communication. Even in prehistoric times, Native Americans built villages here—earthen mounds and cemeteries have been found along Moccasin Bend and on Williams Island, where the Shawnee Trail began.

In the 18th century, French traders established a post here and traded with Native Americans for 50 years. English traders established a post at Fort Loudoun. During the American Revolution, there were Native American raids against the white settlements all along this frontier until Major James Ore broke their power in 1774.

In 1803, John Brown, a man of partial Cherokee descent, established a ferry at the south end of Williams Island. Called Ross' Landing after 1815, this trading post became the first white settlement and the military post from which the Native Americans were removed to the West in 1838. The town was laid out in 1838 and Ross' Landing became Chattanooga. Its river trade expanded through the 1840s, and from the 1850s the railroads provided a new form of traffic. The town's location continued to allow it more traffic than its size would indicate.

Several important battles of the Civil War have occurred at Chattanooga, and they are commemorated by many monuments and plaques throughout the area. In the summer of 1863, Union troops renewed their campaign to split the eastern and western Confederate troops, and the Confederates were driven back to the Tennessee River. Heavy fighting at Chickamauga resulted in a Confederate victory, though there were thousands of casualties on both sides. Gen. Braxton Bragg's Confederates then entrenched themselves on Lookout Mountain and along Missionary Ridge. Gen. Ulysses S. Grant came in October 1863 to resolve these difficulties, and

on his orders, Gen. Joe Hooker's troops first captured the Confederate outpost at Orchard Knob. On November 24, General Hooker's men advanced up the side of Lookout Mountain to attack General Walthall's Confederates, and the "Battle above the Clouds" was fought in a thick mist until 2 a.m. on November 25. The Federals prevailed. The Battle of Missionary Ridge, one of the greatest charges of the war, was fought on November 25. Gen. George H. Thomas's troops assaulted the Confederate rifle pits at the base of the ridge, and then, without orders, stormed the crest and scattered the Confederate line. The broken Confederate Army of Tennessee retreated back into Georgia. Chattanooga became a Union military camp until the war's end, and became the base for Sherman's Atlanta campaign.

Following the devastation of the war, two floods (1867 and 1875), and cholera, yellow fever, and smallpox epidemics (1873, 1878, and 1883), the city was rebuilt and enjoyed great expansion. On Lookout Mountain and elsewhere, the Chickamauga and Chattanooga National Military Parks were established in 1895. Lookout Mountain and Signal Mountain were promoted as recreational resorts for tourists. Adolph Ochs came in the 1870s and founded the *Chattanooga Daily Times*. Zeboim Cartter Patten founded the Chattanooga Medicine Company and Volunteer State Life Insurance Company, and his son-in-law, John T. Lupton, became wealthy by bottling Coca-Cola. His was the first franchised bottling plant. It opened in 1899.

Many manufacturing enterprises were attracted to the city by its abundance of raw materials, access to transportation, and cheap labor. In later years, electric power and railroad facilities figured prominently in its growth. Chattanooga now leads the South in the manufacture of foundry, oil well, and other iron and steel equipment, and in hosiery, furniture, and patent medicines. There are more than 500 Chattanooga-based manufacturers producing 1,500 different articles. The advent of the Tennessee Valley Authority in the 1930s materially stimulated the economic growth of the city, and its progress continues today.

One
APPROACHING
CHATTANOOGA

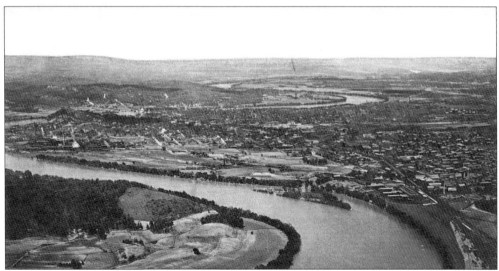

CHATTANOOGA, TENNESSEE, FROM POINT, LOOKOUT MOUNTAIN. Lookout Mountain, nearly 1,800 feet high, affords the most magnificent view possible of Chattanooga. The Tennessee River winds around the foot of the mountain, and Chattanooga lies on a broad plain at its base amid picturesque vistas seen in very few places in the world. (Published by Raphael Tuck and Sons, London; series 2462.)

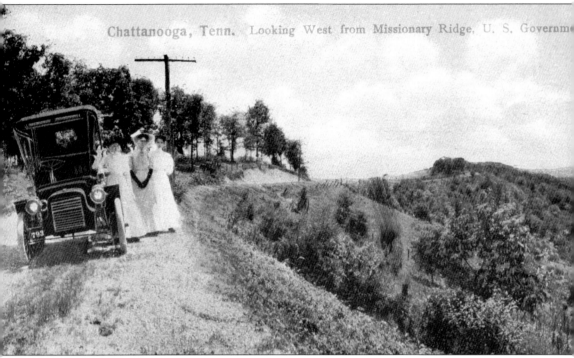

LOOKING WEST FROM MISSIONARY RIDGE FROM GOVERNMENT BOULEVARD. In the center of the Chattanooga area, Missionary Ridge stretches south from the Tennessee River for about

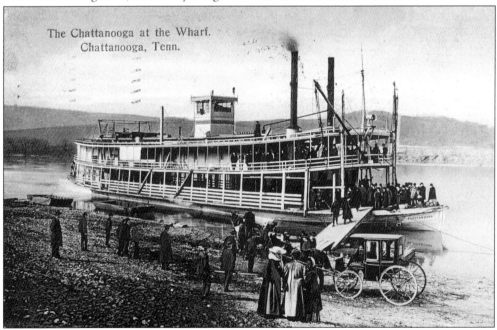

The Chattanooga at the Wharf.
Chattanooga, Tenn.

THE *CHATTANOOGA* AT THE WHARF. River traffic was frequent, both commercial and residential. This boat was evidently used by tourists or regular travelers, as indicated by the number of people already aboard. The horse and buggy seems to be elite equipment. (Published by S.H. Kress; postmarked 1909.)

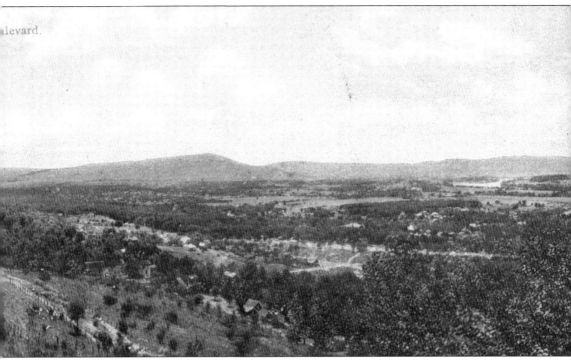

20 miles and rises to a height of 400 feet. This early picture (*c.* 1908) shows several ladies navigating their motorcar along the unpaved road.(Published by Albin Hajos, Chattanooga.)

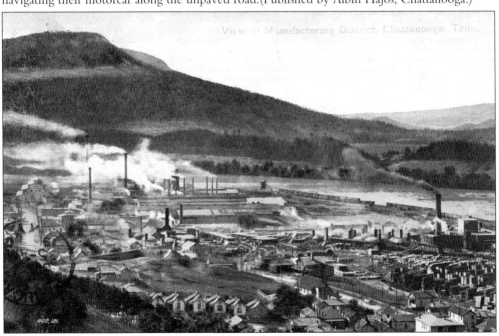

VIEW OF THE MANUFACTURING DISTRICT. This view showing factories or foundries at work also includes workers' houses (left foreground). The area of Chattanooga lying south of the railroad tracks was heavily industrialized by the 1870s. (Published by J.J. Pettus, Chattanooga; postmarked 1909.)

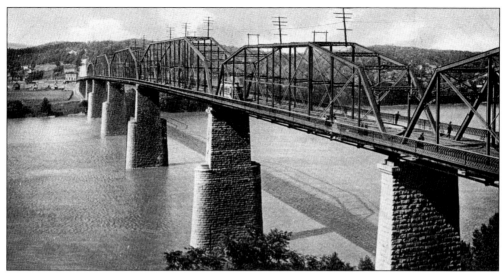

TENNESSEE BRIDGE ACROSS TENNESSEE RIVER. The bridge spanning the Tennessee River at Walnut Street was built at a cost of $233,500 and opened to the public February 18, 1891. It is 2,370 feet long and rises 100 feet above the water. It was the first bridge across the Tennessee River at Chattanooga since the military bridge was washed away by the 1867 flood. Due to its age and structural problems, the bridge was closed to traffic in 1978. It is presently used as a pedestrian walkway. (Published by Raphael Tuck and Sons, London; series 2463.)

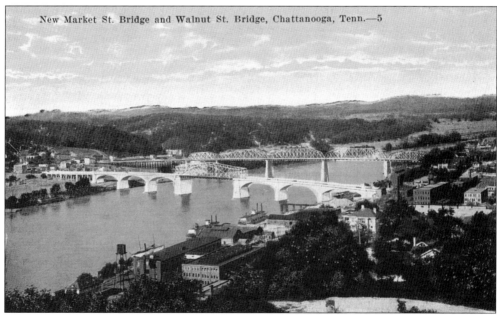

NEW MARKET STREET BRIDGE AND WALNUT STREET BRIDGE. Built at a cost of $1 million in 1917, the Market Street Bridge (the present-day John Ross Bridge) parallels the Walnut Street Bridge across the Tennessee in concrete splendor. The bridge is made of concrete (except for the middle span, which is a bascule lift) and occupies the site of the military bridge constructed by the Federals during the Civil War. (Published by E.C. Kropp, Milwaukee.)

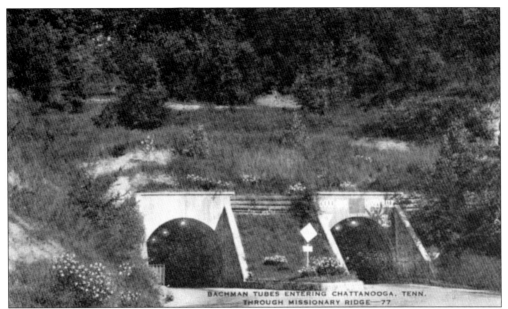

BACHMAN TUBES ENTERING CHATTANOOGA, TENNESSEE, THROUGH MISSIONARY RIDGE. Entering downtown Chattanooga from the east by automobile, one must proceed through these tunnels, which have been blasted into the base of Missionary Ridge. These well-lighted passageways through the ridge provide a much easier entrance than would be possible if one had to go over the top. (Published by Chattanooga Magazine Co.)

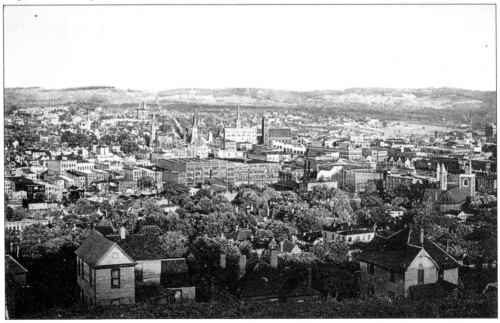

CHATTANOOGA AND MISSIONARY RIDGE. This 1902 photograph of the city is too distant to discern much detail; however, the Times Building dome may be seen at center, between the First Methodist and First Baptist churches. Seen in the foreground (right) are the Second Presbyterian and St. Paul's Episcopal churches. All four were built 1882–1892. (Published by Detroit Publishing Co.)

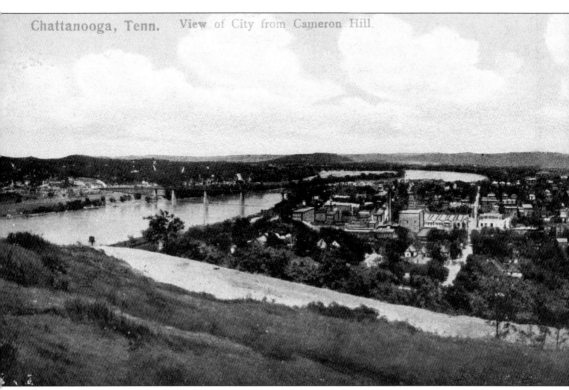

VIEW OF THE CITY FROM CAMERON HILL. Cameron Hill, rising at the edge of downtown Chattanooga, was utilized during the Civil War by the signal corps of both armies. The Cameron

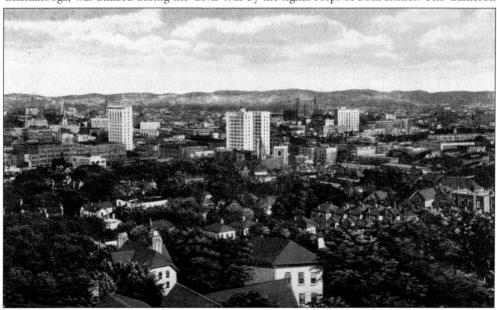

BIRD'S-EYE VIEW OF CHATTANOOGA, "THE DYNAMO OF DIXIE." Another view from Cameron Hill shows the city *c.* 1915. Several "skyscrapers," as well as other handsome buildings, have made their appearance,. The square tower of St. John's Episcopal can be seen at center. (Published by T.H. Payne, Chattanooga.)

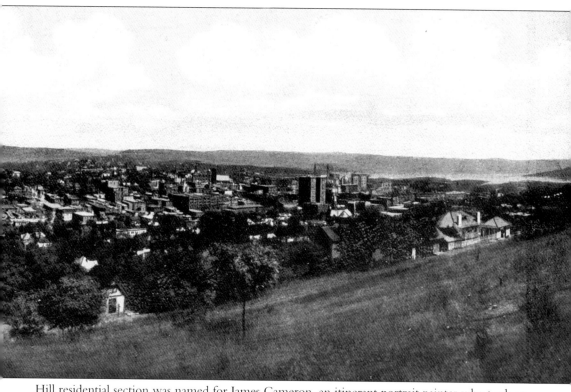

Hill residential section was named for James Cameron, an itinerant portrait painter who took up permanent residence there *c.* 1852. (Published by Albin Hajos, Chattanooga.)

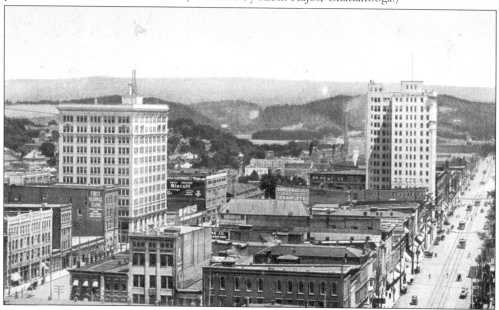

MARKET STREET FROM PATTEN HOTEL. One of the main arteries of the city, Market Street reveals the transport of changing times: horse and carriage, trolley, and automobile. Two of the principal downtown buildings pictured are the James Building (left) and the taller Hamilton Bank Building. (Published by Detroit Publishing Co.; postmarked 1917.)

17

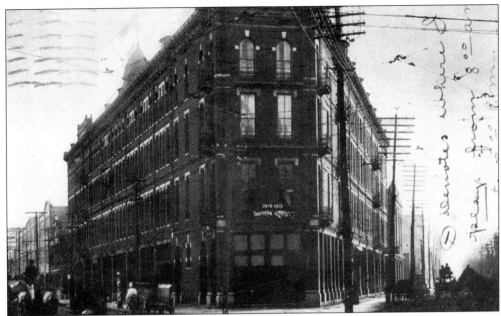

SOUTHERN HOTEL. This *c.* 1900 card has been somewhat defaced by the sender, presumably as a joke. His message reads: "x denotes where I play from 8 a.m. to 5 p.m.," and he has titled the card "Our General Office." He has scratched out the word "Hotel" in the picture just over the door. The Southern Hotel was located at the intersection of Chestnut, Carter, and Ninth Streets. Much later it housed the Railway Express Offices. (Published by MacGowan-Cooke Printing Co., Chattanooga; postmarked 1910.)

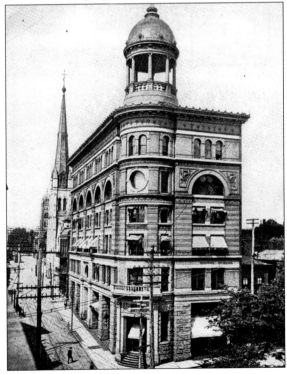

TIMES BUILDING. The Chattanooga Times Building (the Dome Building) was erected at the corner of Eighth Street and Georgia Avenue in 1891 by DeLemus and Cordes, architects from New York. It heralded the Classical revival in Tennessee architecture. The combination of elements makes the building unique; it has become a famous Chattanooga landmark. *The Times* moved in 1941 to another building on East Tenth Street. (Published by MacGowan-Cooke Printing Co.)

Two
BUILDINGS, BUSINESSES, AND MEMORIALS

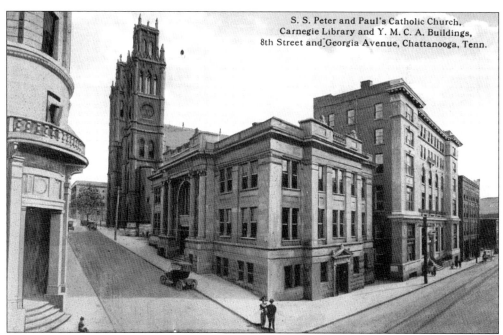

S. S. Peter and Paul's Catholic Church,
Carnegie Library and Y. M. C. A. Buildings,
8th Street and Georgia Avenue, Chattanooga, Tenn.

PETER AND PAUL'S CATHOLIC CHURCH, CARNEGIE LIBRARY, AND YMCA BUILDING. An early scene of an interesting block (Eighth Street and Georgia Avenue), this view also shows the rounded entrance to the Times Building (left). The automobiles indicate that the photo was made *c.* 1912. (Published by S.H. Kress.)

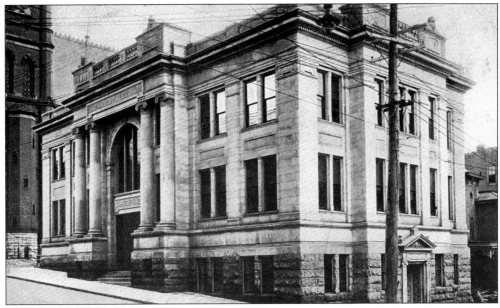

CARNEGIE LIBRARY. Located across from the Times Building, the Carnegie Library on the corner of Georgia and East Eighth Streets opened in 1905. The building was given by Andrew Carnegie and furnished with gifts from various citizens. Its style is typical of the assimilation of classicism into American architecture. (Published by International Post card Co., New York; postmarked 1908.)

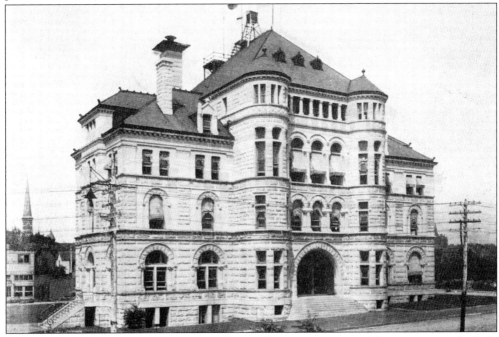

U.S. CUSTOM HOUSE. The U.S. Post Office and Custom House at Chattanooga was built in 1893 at East Eleventh and Lindsay Streets. The building was enlarged during the 1930s and was used for Tennessee Valley Authority offices. Its heavy stone structure is in the Romanesque-revival tradition. (Published by MacGowan-Cooke Printing Co.)

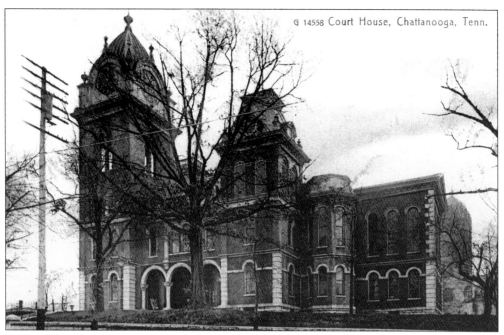

G 14558 Court House, Chattanooga, Tenn.

COURT HOUSE. The beautiful old court house building, pictured in many early views of Fountain Square, was struck by lightning and burned May 7, 1910. (Published by Rotograph Co., New York.)

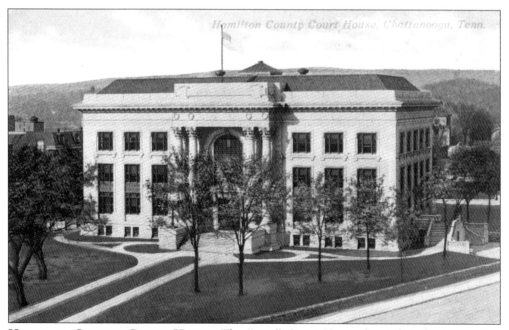

Hamilton County Court House, Chattanooga, Tenn.

HAMILTON COUNTY COURT HOUSE. The "new" Court House, located at the intersection Georgia Avenue, Lookout Street, and East Sixth Street, replaced the one that burned in 1910. It was constructed in the Classical tradition of Tennessee marble and was completed in 1913. (Published by S.H. Kress.)

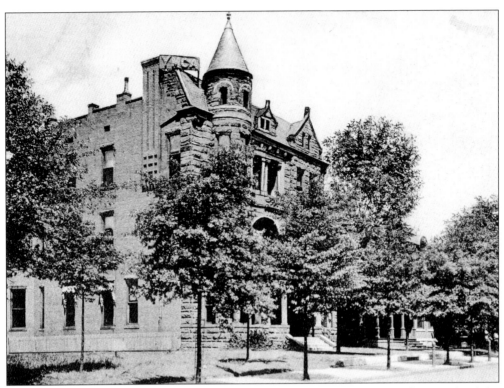

CHATTANOOGA YMCA. This early postcard view shows the "old" YMCA that pre-dated the 1909 structure. It was located at 117–110 McCallie Avenue in 1903. (Published by Raphael Tuck and Sons, London; postmarked 1906.)

"A TWO-HUNDRED THOUSAND DOLLAR BUILDING." The YMCA in Chattanooga dates from 1871. The building pictured is apparently a "new" building. This structure, dedicated January 31, 1909, is located at 812 Georgia Avenue. (Published by CCCC Co.)

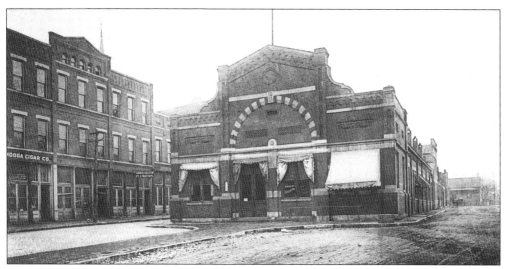

CITY HALL. The old Market House on Georgia Avenue near Ninth Street (present-day Patten Parkway) was converted into a city hall under the administration of Mayor George Ochs. It was used until 1908. (Published by Rotograph Co., New York.)

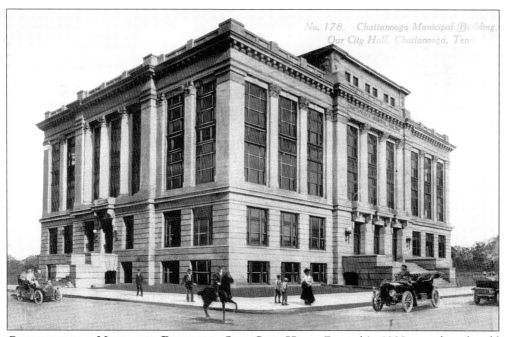

CHATTANOOGA MUNICIPAL BUILDING: OUR CITY HALL. Erected in 1908 to replace the old city hall on Georgia Avenue (near Ninth Street), this municipal building is one of the architectural projects of Reuben H. Hunt, a noted local architect. (Published by S.H. Kress; postmarked 1910.)

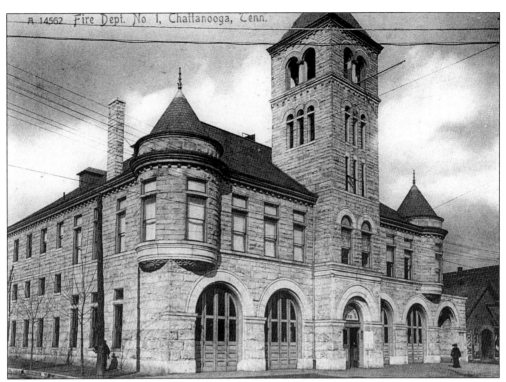

A 14562 Fire Dept. No 1, Chattanooga, Tenn.

FIRE DEPARTMENT NO. 1. This ponderous stone building in the style of R.H. Hunt was located at the corner of Carter and Eleventh Streets. No equipment is seen; a woman dressed in black stands in front. (Published by Rotograph Co., New York.)

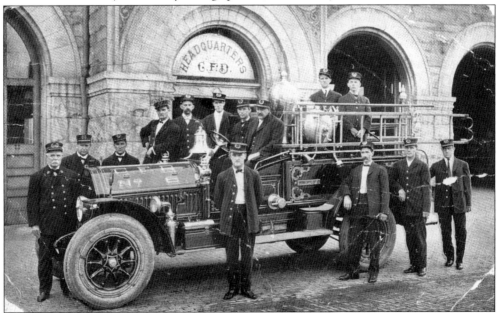

FIRE TRUCK AND FIREFIGHTERS. These firefighters, obviously proud of their calling and their equipment, pose in front of the No. 1 Fire Department building. This fire truck is an interesting example of an early model. (Published by S.H. Kress; postmarked 1916.)

24

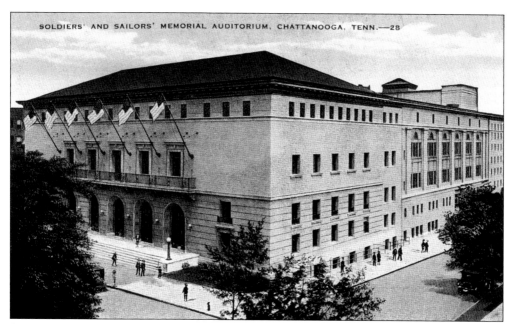

SOLDIERS' AND SAILORS' MEMORIAL AUDITORIUM. Located on McCallie Avenue at Lindsay Street, the Memorial Auditorium was designed by R.H. Hunt in 1922. It memorializes soldiers and sailors who died in World War I and occupies an entire block. It has a seating capacity of 5,500 people. (Published by D.R. Weill, Chattanooga.)

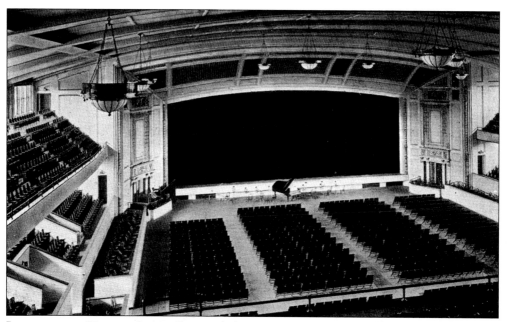

INTERIOR OF SOLDIERS' AND SAILORS' AUDITORIUM. At a cost of $1 million dollars, this building exemplifies the best in auditorium planning. It can accommodate an audience of 5,500 and has a stage capacity of 500. It was planned so that six conventions could take place simultaneously without interfering with each other. Amenities include a large organ, a smaller theater, and meeting rooms. (Published by Andrews Printery, Chattanooga.)

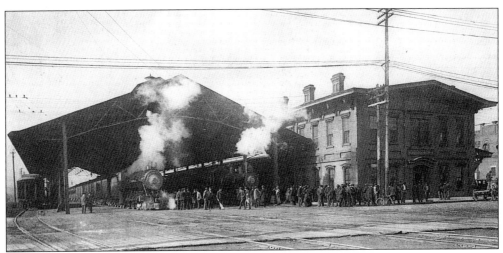

CENTRAL PASSENGER STATION. Situated in the crowded, busy railroad center of downtown Chattanooga, the Central Passenger Station was the hub of activity at Thirteenth and Market Streets until 1909. Since this location was chaotic and overcrowded, the Southern Railway Co. built a new depot in the 1400 block of Market Street. (Published by Rotograph, New York.)

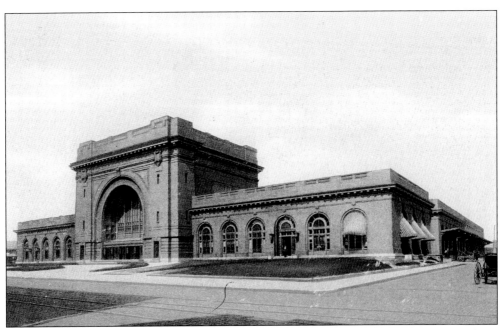

NEW TERMINAL STATION. This beautiful building, originally known as the Southern Railway Terminal, was built in 1909 and served railway travelers until the "Georgian" completed its last run in 1971. Designed by Don Barber of New York, it is located at 1434 Market Street on the site of the old Stanton House. In 1973, it reopened as the Chattanooga Choo-Choo, which is a complex housing hotel rooms, shops, and restaurants. (Published by Detroit Publishing Co.)

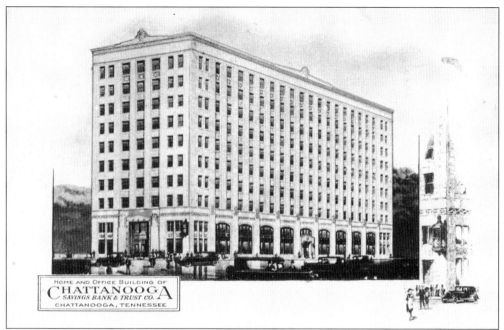

CHATTANOOGA SAVINGS BANK AND TRUST CO. One of the newer structures in the downtown area, the Chattanooga Bank Building was erected in 1928 on the northeast corner of Broad and Eighth Streets. It claimed to be "one of the most beautiful of such structures in the South." Its exterior was finished entirely of granite and terra cotta. (No publishing data available.)

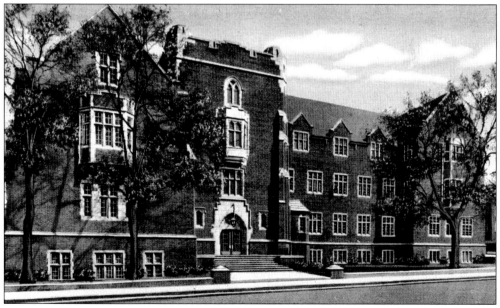

CHATTANOOGA PUBLIC LIBRARY. This building is located at the west corner of the University of Chattanooga (presently the University of Tennessee) campus and McCallie Avenue. It housed both the Chattanooga Public Library and the University of Chattanooga Library from 1939 to 1976, when the public library moved to the center of the city. (Published by T.H. Payne, Chattanooga.)

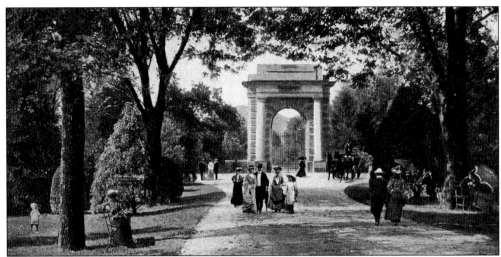

MAIN ENTRANCE TO NATIONAL CEMETERY. The National Cemetery spreads over 20 blocks within the city, with its main entrance at the south end of National Avenue. It is the burial place of over 15,000 veterans of every war in U.S. history; however, about one-third of the graves are those of unknown soldiers killed in the battles of Chickamauga and Missionary Ridge. The Andrews raiders are buried here, under a reproduction of their captured locomotive, the "General." (Published by Raphael Tuck and Sons, London; series 2176.)

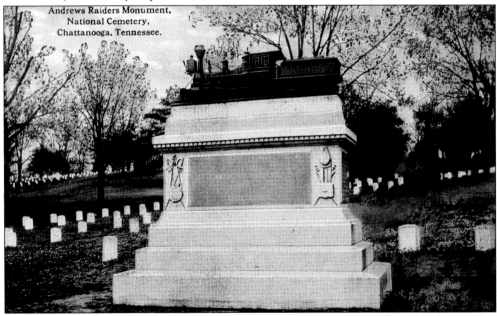

ANDREWS RAIDERS MONUMENT, NATIONAL CEMETERY. This is the monument erected to honor the Andrews raiders. On April 12, 1862, along with seven companions disguised as civilians, Capt. James Andrews, a Federal spy, seized the "General" at Big Shanty (presently Kennesaw, Georgia) and proceeded northward in an attempt to cut Confederate communications between Atlanta and Chattanooga. They were followed by W.A. Fuller and an associate on a handcar, and later, on another engine. Within a week, the raiders were captured. In June 1862, Andrews and his companions were publicly hanged as spies in Atlanta. The "General" now resides at Kennesaw. (Published by Read House Cigar Co., Chattanooga.)

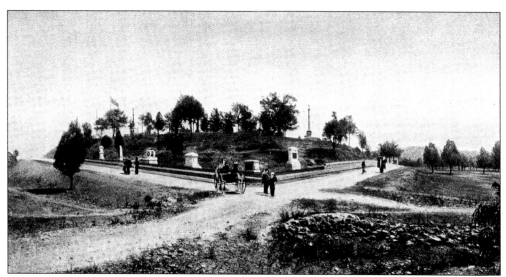

ORCHARD KNOB. The Orchard Knob area, located between Ivy and East Fifth Streets, was purchased by the federal government in 1894. From this place in November 24–25, 1863, Gen. Ulysses S. Grant and Gen. George H. Thomas directed the Union forces in the battles of Lookout Mountain and Missionary Ridge. The earthworks and cannon are well preserved, and historical markers give accounts of military movements. (Published by Raphael Tuck and Sons, London; series 2176.)

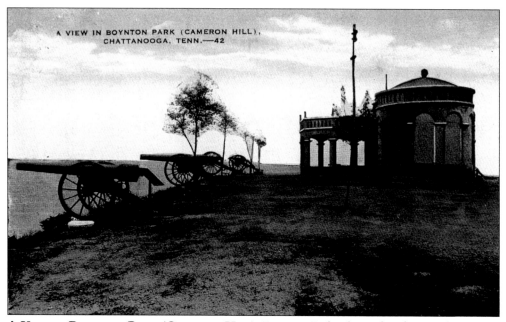

A VIEW IN BOYNTON PARK (CAMERON HILL). Boynton Park is located on historical Cameron Hill at the edge of downtown Chattanooga. It affords a magnificent view of the Tennessee River for miles in either direction as it curves around Lookout Mountain at Moccasin Bend. The cannons are reminders of the Civil War activity here. The park was named for Henry V. Boynton, who was wounded in the Battle of Missionary Ridge. He was one of the first to suggest that the battlefields should be preserved and marked. (Published by D.R. Weill, Chattanooga.)

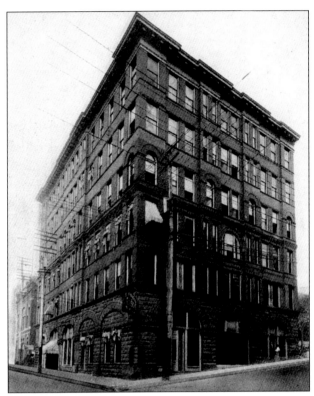

TEMPLE COURT: "THE ONLY EXCLUSIVE LAWYER'S OFFICE BUILDING IN THE SOUTH." The sender of this *c.* 1910 card writes, "This building looks like it should hold all the lawyers we need, yet it only contains a small part of what we have." Temple Court was located at 624 Cherry Street. (Published by MacGowan-Cooke Printing Co., Chattanooga.)

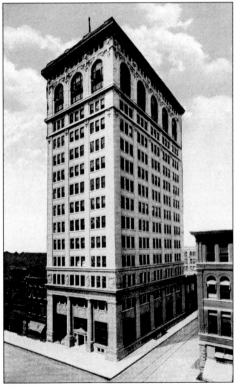

HAMILTON NATIONAL BANK BUILDING. This postcard shows the "new skyscraper" built in 1911 at the corner of Market and Seventh Streets. Not the first of the Hamilton banks, this building was the harbinger of other skyscrapers in the city and numerous branch banks scattered far and wide. (Published by Read House Cigar Co., Chattanooga.)

THE JAMES BUILDING. Built in 1908 at the corner of Broad and Eighth Streets, the James Building has the distinction of being Chattanooga's first "skyscraper." Reuben H. Hunt, a resident of Chattanooga for many years, was the architect. Other examples of his work may be seen in Chattanooga and in many other cities. (Published by L.J. Pettus, Chattanooga.)

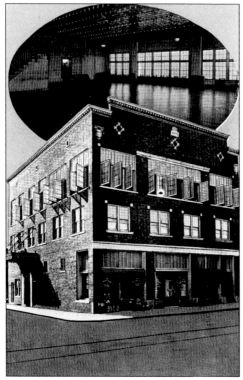

DR. J.C. TADLEY BUILDING. The Tadley Office Building was erected in 1928 at the corner of Ninth and Douglas Streets. A special innovation was its Roof Garden Dance Hall, known as "the Home of Good Dancing," which could accommodate 800 people. (Published by Tichnor Quality Views.)

31

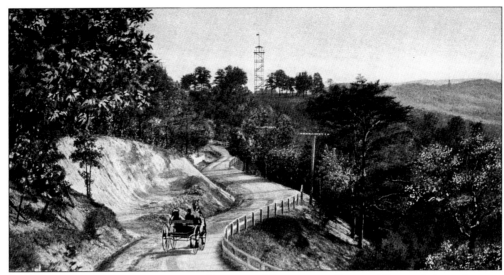

GOVERNMENT BOULEVARD ON THE CREST OF MISSIONARY RIDGE. The road along the crest of Missionary Ridge gives travelers beautiful vistas of the Chattanooga country. In this *c.* 1907 view, a carriage approaches the Bragg tower, where Gen. Braxton's Bragg's headquarters were located in November 1863. (Published by Raphael Tuck and Sons, London; series 2176.)

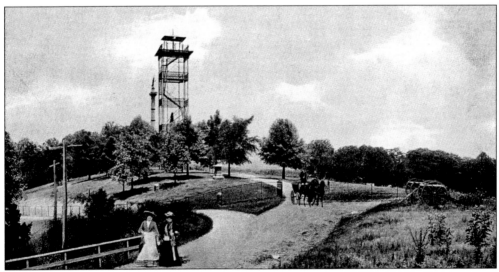

POINT OF GENERAL BRAGG'S HEADQUARTERS DURING THE BATTLE OF MISSIONARY RIDGE, 1863. The observation tower, now removed, signifies the point from which Confederate Gen. Braxton Bragg watched the Battle of Missionary Ridge. His headquarters were located in a small house on the summit of the ridge. The Illinois monument can be seen just beyond the tower. (Published by Raphael Tuck and Sons, London; series 2463.)

ILLINOIS MONUMENT ON MISSIONARY RIDGE. Located near General Bragg's headquarters on Missionary Ridge, the Illinois monument is only one of many memorials seen on Crest Road. It is a circular, marble shaft with four charging soldiers at the base and an angel of mercy at the top. (Published by Souvenir Post card Co., New York.)

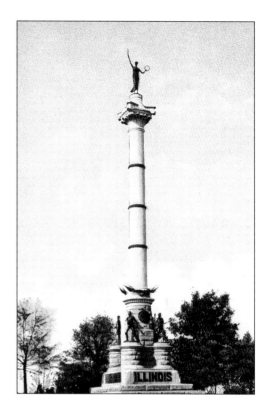

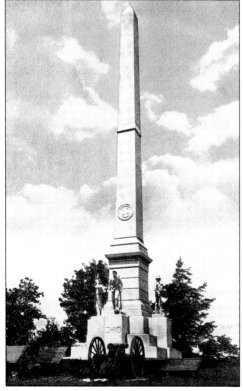

OHIO STATE MONUMENT, MISSIONARY RIDGE. The Ohio monument is an obelisk-shaped column with soldiers at the base and cannons in front. Many states are represented by these sobering and beautiful memorials. (Published by T.H. Payne, Chattanooga.)

33

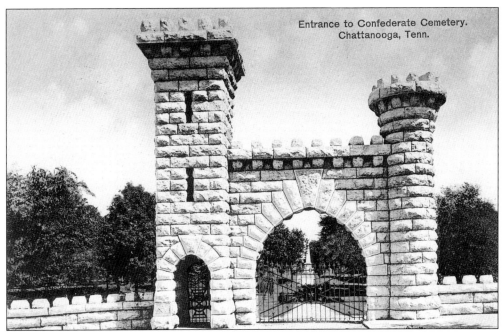

ENTRANCE TO CONFEDERATE CEMETERY. Extending from East Third to East Fifth Streets, between Lansing and Palmetto Streets, the Confederate Cemetery is flanked by the Citizens' and Jewish cemeteries. Only the graves of veterans buried in recent years are mounded or marked. Tablets along the walks commemorate soldiers from various states. (Published by S.H. Kress; postmarked 1908.)

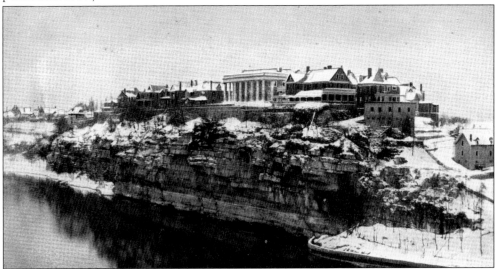

BLUFF VIEW, AFTER A SNOW STORM. The bluffs of the Tennessee River form one of the famous picturesque spots in Chattanooga. Before the Civil War, there was an iron smelting plant known as Bluff Furnace located here. It was demolished during the war when the bluffs became a lookout point and garrison site for both Confederate and Union forces. Later, a number of fine Victorian homes were built here. Prominent among them was the 1906 Classical revival mansion owned by George Thomas Hunter, which later became the Hunter Gallery of Art. (Published by S.H. Kress.)

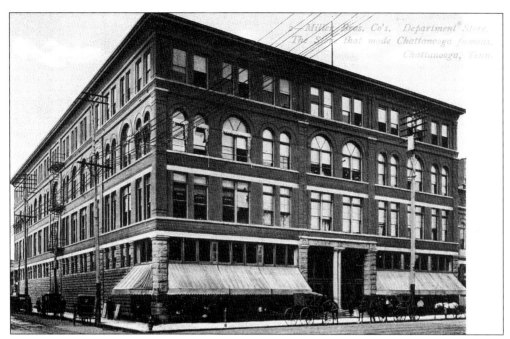

MILLER BROTHERS COMPANY'S DEPARTMENT STORE. Miller's was founded in Chattanooga in 1888 and had its first store at 519 Market Street, which was subsequently burned. Presently located at the corner of Market and Seventh Streets, it is one of Tennessee's largest stores and is considered "the store that made Chattanooga famous." (No publication data available.)

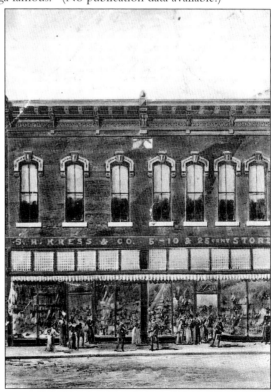

KRESS'S CHATTANOOGA, TENNESSEE STORE. One of the fastest-growing chain stores at the turn of the century, Kress, along with Woolworth, pioneered the "5-and-10¢" mind-set of shoppers. This early card hardly suggests the growth and modernity of the later stores in Chattanooga and elsewhere. The store was located at 803 Market Street. (No publication data available.)

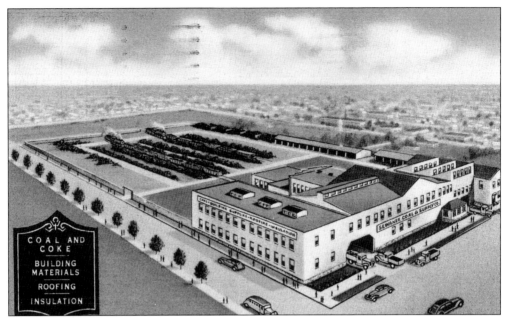

SEWANEE COAL AND SUPPLY CO. A typical advertising card of the period, this "linen" postcard has the following message printed in bold face on the reverse: "Hardwood-charcoal. Call Sewanee Coal and Supply Co. 7-2191." It was located in the industrial section of the city at 1038 East Main Street. (Published by Harry G. Brown, Chattanooga; postmarked 1947.)

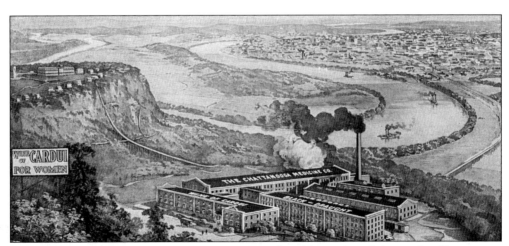

CHATTANOOGA MEDICINE CO. An interesting advertising postcard shows the Chattanooga Medicine Co. with its outstanding products, Wine of Cardui for Women and Black Draught, prominently displayed on the building's roofs. Lookout Mountain and Moccasin Bend, with Chattanooga in the distance, are charmingly portrayed—even the incline and Lookout Inn (top) are shown. Its location is shown as being at 1715 West Thirty-eighth Street at the foot of Lookout Mountain. (No publication data available; postmarked 1906.)

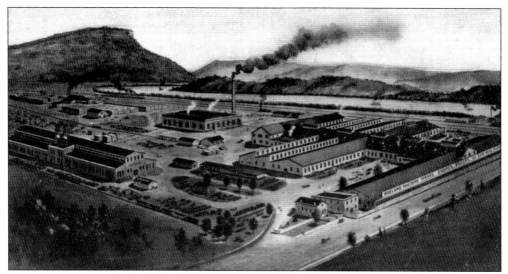

WHELAND MACHINE WORKS. The Wheland Co. was established *c.* 1870 by George W. Wheland with a foundry just south of Chattanooga Creek. A machine shop and a blacksmith shop were included, and the foundry experienced great success in the 1870s and 1880s. Continuing into the 1990s, the company manufactures drilling equipment, steam engines, sawmill outfits, and much more. It is the largest independent producer of cast–iron automotive brake components in the United States. (Published by Simplicity Co., Chicago.)

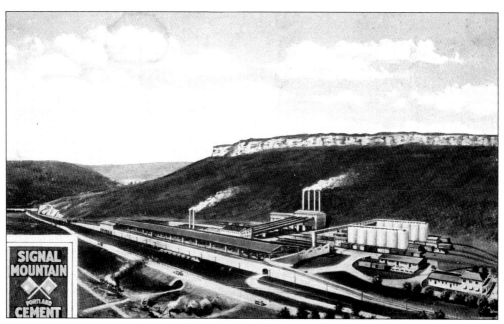

SIGNAL MOUNTAIN PORTLAND CEMENT CO. PLANT. A favorite kind of advertising card is shown here, featuring the landscape and neat layout of the buildings. The address of the company is Suck Creek Road, RD5. (Published by Harry G. Brown, Atlanta; postmarked 1924.)

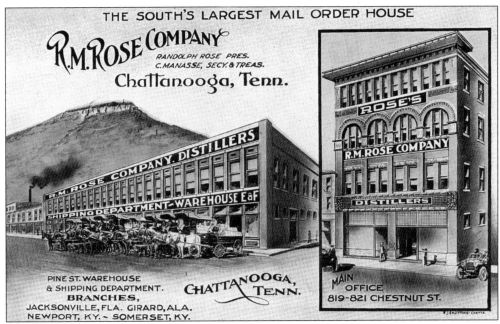

R.M. ROSE CO., "THE SOUTH'S LARGEST MAIL-ORDER HOUSE." A Victorian-style information card tells us almost all we need to know about R.M. Rose Co.. The row of horse-drawn wagons in the picture indicates an early date (*c.* 1905), even though an automobile peeks around the corner at right. (No publication data available.)

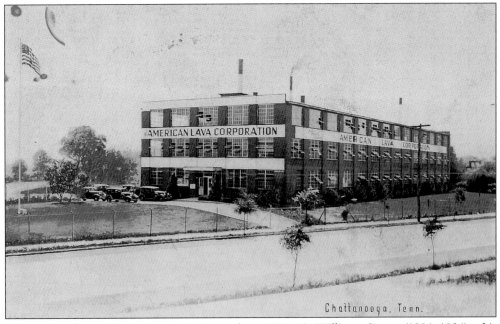

AMERICAN LAVA CORPORATION. Located at 1411–19 Williams Street (1904–1936), this building does not suggest the modernistic improvements made to the later building at Cherokee Boulevard and Manufacturers' Road. As this 1930s picture suggests, it was a large and successful business. (No publication data available.)

38

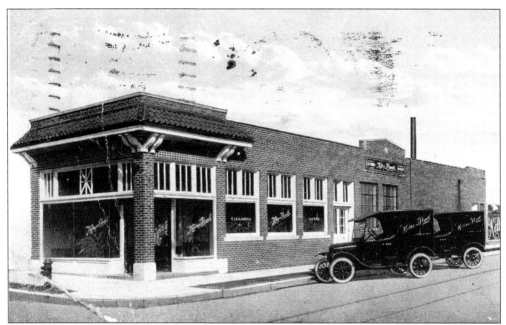

KELLY AND POWELL, CLEANERS AND DYERS. In the 1920s, Kelly and Powell had a neat-looking dry cleaning business at the corner of Central Avenue and East Eighth Street. The delivery trucks parked outside and the ferns in the windows indicate a "class" establishment. (Published by Curt Teich, Chicago; postmarked 1925.)

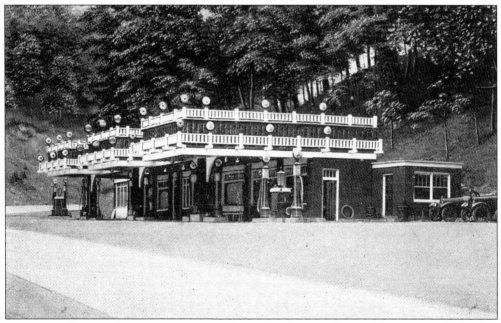

CHEROKEE SERVICE STATION. This advertising card informs us that the Cherokee Service Station is "the South's largest and most beautiful filling station, located at the Dixie Highway, handling 9 different brands of gasoline and 17 different brands and grades of motor oils, battery service, high grade vulcanizing tires, tubes, and accessories. (Published by Andrews Printery, Chattanooga.)

LAPSLEY R. CALDWELL and his friends, who are prospective "Southern Beauties."

Scene taken from Lookout Mountain near where "Southern Beauty" Enameled Ware is made.

Compliments of

THE CAHILL IRON WORKS

Manufacturers of

"Southern Beauty" ENAMELED WARE

CHATTANOOGA,　：　TENNESSEE

"LAPSLEY R. CALDWELL AND HIS FRIENDS. . ." The Cahill Iron Works are not pictured here, but this card advertises the "Southern Beauty" enamel-ware produced there. The factory was located near the river at Twenty-third Street and the NC & St. L Railway. (No publication data available.)

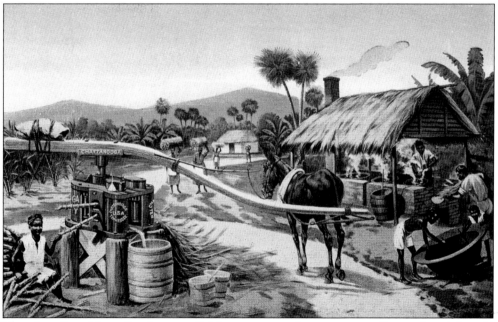

THE OLD RED MILL, "IN JAMAICA," MADE BY THE CHATTANOOGA PLOW CO. A fanciful painting portrays an imaginary situation in Jamaica in which primitive workers make use of one of Chattanooga Plow Co.'s devices. The company was located at the corner of West Main and Carter Streets. (Published by Curt Teich.)

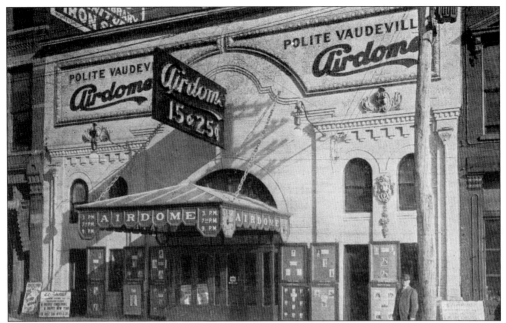

AIRDOME—CHATTANOOGA'S LEADING VAUDEVILLE THEATER. The Airdome, announcing "polite vaudeville," was the only theater in Chattanooga built expressly for "summer amusements." It had a 12-horsepower cooling plant and a movable roof. The management claimed to show vaudeville surpassing in quality any other show in the South. Lady patrons were given handsome souvenirs every Wednesday afternoon, and children were given keepsakes every Saturday afternoon. Matinees cost 10¢; regular admissions were 15 and 25¢. There were three shows a day. The theater was located on Market Street next to T.H. Payne Co. (Published by International Post Card Co., St. Louis.)

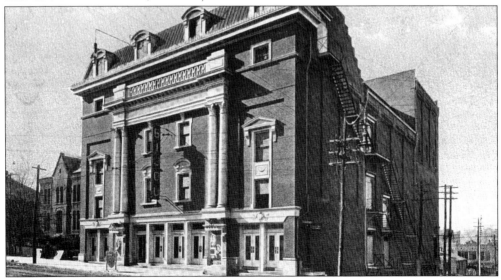

BIJOU THEATER. Located at the corner of Walnut and Sixth Streets, the Bijou was destroyed by fire December 19, 1943. This early picture shows the building before the outside ticket booth and marquee were added—sure indications of a shift to movie presentations. (Published by International Post Card Co., New York.)

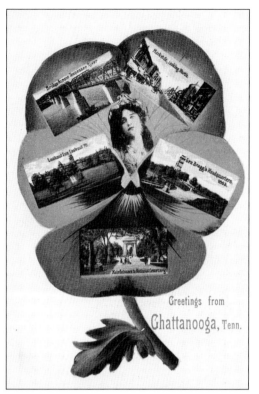

"GREETINGS FROM CHATTANOOGA." One of the popular types of greeting postcards, the pansy card always pictured a pretty girl in the center with several vignettes of city views around her on the petals. Here we see Walnut Street Bridge, Market Street, Bragg's Headquarters, Entrance to National Cemetery, and Lookout Inn. The pansy series was published *c.* 1907 and featured many U.S. cities. (Published by L.J. Pettus, Chattanooga.)

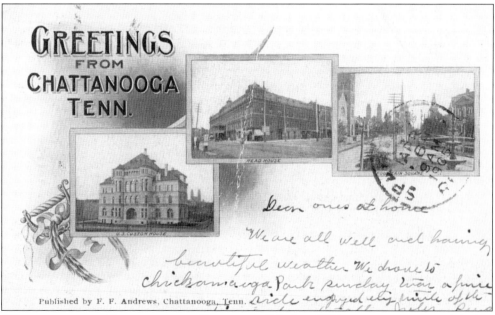

"GREETINGS FROM CHATTANOOGA, TENNESSEE." Before 1907, messages on postcards had to be written on the front of the card; only the name and address of the recipient were allowed on the back with the stamp. This is such a card; usually there were three or four vignettes and enough space to write a very short message. (Published by F.F. Andrews, Chattanooga; postmarked 1905.)

Three

PERSONAL LIFE
AND EDUCATION

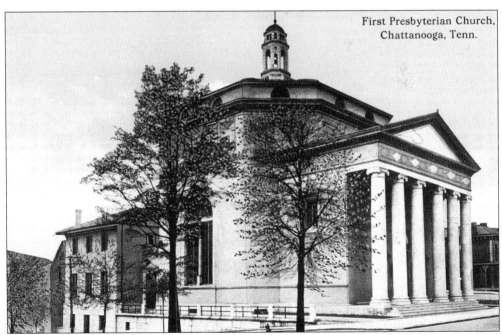

First Presbyterian Church,
Chattanooga, Tenn.

FIRST PRESBYTERIAN CHURCH. Located on the southwest corner of McCallie Avenue and Douglas Street, the First Presbyterian Church was designed by McKim, Mead, and White. It was constructed in 1910 in the Italian Renaissance style. The six large, art-glass windows were designed by E.H. Blashfield. (Published by S.H. Kress.)

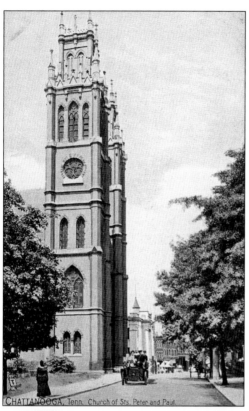

CHURCH OF SAINTS PETER AND PAUL. This cathedral, built in 1890 at 214 East Eighth Street, stands on a hill in the downtown area. It is the home of the first permanent Catholic congregation in Chattanooga. Gothic in style, it is made of brick with trimmings of Tennessee marble. It cost $155,000 to build. The architect was Peter Dedericks Jr. of Michigan. (Published by Raphael Tuck and Sons, London; series 2587.)

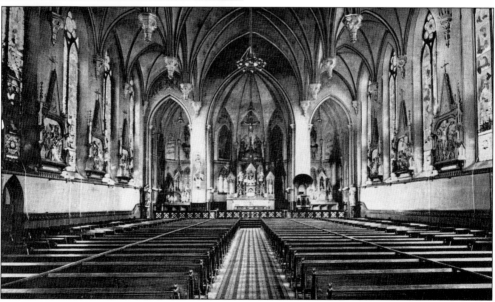

INTERIOR OF STS. PETER AND PAUL CHURCH. Many outstanding features can be seen inside the Church of Sts. Peter and Paul. Among them are the groined, vaulted ceiling, the notable Stations of the Cross, and a series of 14 stained-glass windows. Each window in the church measures 6 feet by 30 feet and depicts events in the lives of the two saints. (Published by DG, New York; postmarked 1909.)

FIRST BAPTIST CHURCH. Erected in 1888, this beautiful church occupies the corner of Georgia Avenue and Oak Street. One of a cluster of treasures at Fountain Square, its Romanesque dignity towers over the courthouse and the Fireman's Memorial Fountain. (Published by International Post Card Co., New York.)

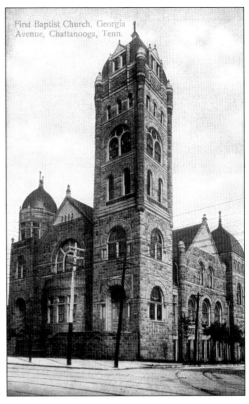

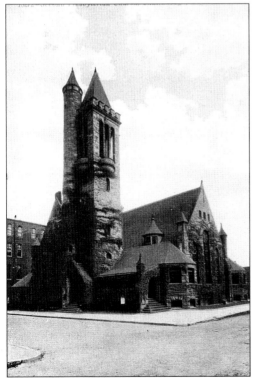

SECOND PRESBYTERIAN CHURCH. This church, located on the southwest corner of Pine and Seventh Streets, has a most unusual tower. Built in 1891 from the designs of Reuben H. Hunt, it makes use of Romanesque themes to create its bold, dynamic form. (Published by Souvenir Post Card Co., New York.)

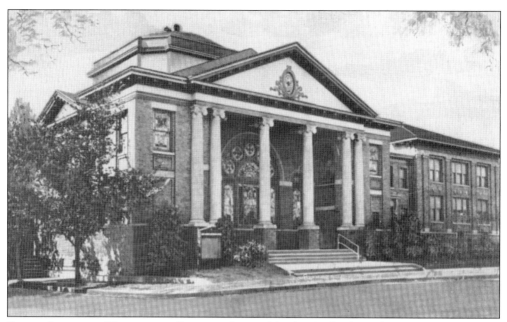

SAINT ANDREWS METHODIST CHURCH. Located in the Orchard Knob community at Beech Street and Union Avenue, Saint Andrews Methodist is designed with Renaissance revival elements. (Published by Target Printing and Lithographing Co., Chattanooga.)

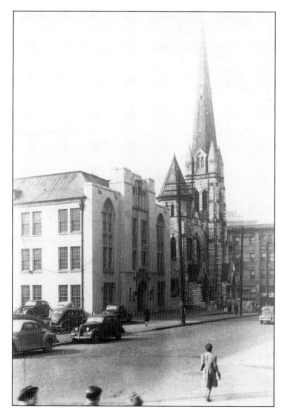

FIRST METHODIST CHURCH. The First Methodist Church, built in 1885 to the design of John W. Adams, shows Gothic influences in its design. It stands on the corner of McCallie and Georgia Avenue. Known as "The Stone Church," its spike steeple is a Chattanooga landmark. (Real Photo; postmarked 1943.)

CENTENARY M.E. CHURCH SOUTH. One of a cluster of significant churches in the downtown area, the Centenary M.E. Church is located at McCallie Avenue and Lindsay Streets. The massive stairways on each corner lend dignity to the Gothic design. (Published by S.H. Kress.)

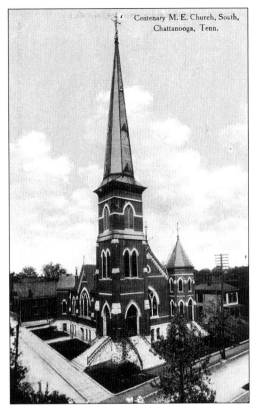

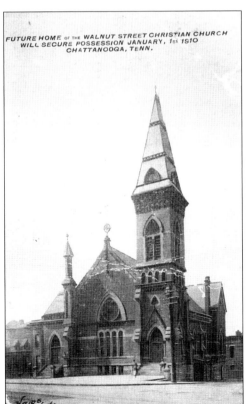

FUTURE HOME OF WALNUT CHRISTIAN CHURCH. This interesting card shows a pre-existing building that will soon have a new congregation. The sender and recipient of the card have apparently been in correspondence about the church before. The sender says, "I can't tell you where the old church book is." (Published by National Colortype Co.; postmarked 1909.)

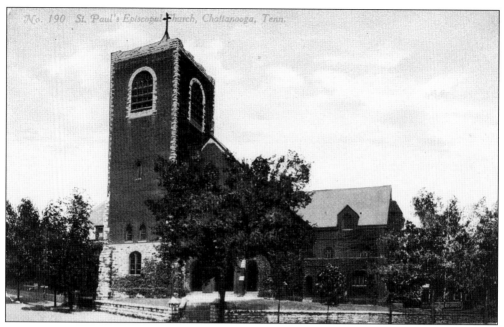

ST. PAUL'S EPISCOPAL CHURCH. Located on the north corner of Pine and Seventh Streets, St. Paul's Episcopal was built in 1888 to the designs of W. Halsey Wood, an Englishman who also designed the Cathedral of St. John the Divine in New York City and the Chapel at Sewanee. St. Paul's parish is "the mother church" of all the parishes in the Chattanooga area. The brick interior is in the Venetian Gothic style; the altar is made of Italian marble with hand-painted art work. (Published by S.H. Kress.)

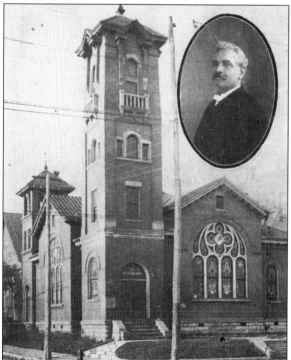

FIRST CONGREGATIONAL CHURCH. This 1912 postcard shows the First Congregational Church, located on East Ninth Street. The moderate-sized church combines in its architecture Romanesque and Gothic elements. Rev. J.E. Smith, the pastor, is also pictured in a dignified portrait. (No publication data available.)

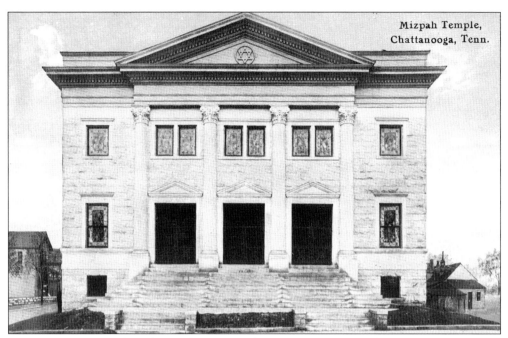

Mizpah Temple, Chattanooga, Tenn.

MIZPAH TEMPLE. The Julius and Bertha Ochs Memorial Temple, first located at Oak and Lindsay Streets, was built by Adolph S. Ochs in honor of his parents. In 1928, a marble-and-brick structure was erected at McCallie and Fairview Streets, and a newer building was dedicated in 1960. (Published by S.H. Kress; postmarked 1912.)

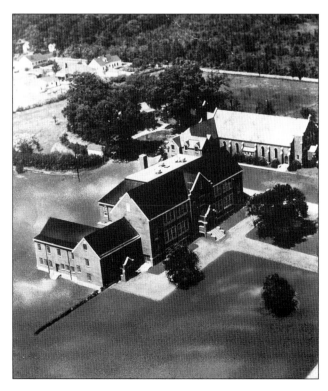

AERIAL VIEW OF PARISH CHURCH AND SCHOOL—OUR LADY OF PERPETUAL HELP. A suburban church built in 1937 with its adjacent school, Our Lady of Perpetual Help occupies rural surroundings at 501 South Moore Road in East Ridge. (Real Photo.)

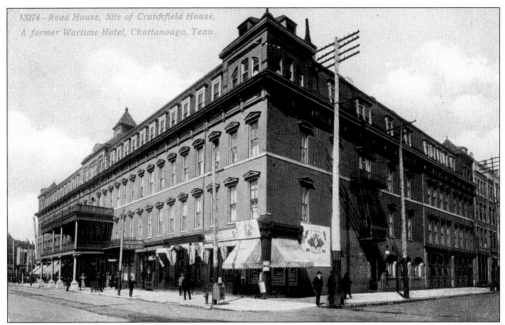

READ HOUSE. The site at West Ninth Street between Broad and Chestnut Streets has been the location of a hotel ever since the Crutchfield House was built here in 1847. Used during the Civil War as a military hospital, the building burned in 1867. It was replaced by this three-story brick building, which opened January 1, 1872, under the management of Dr. and Mrs. John T. Read. It had 50 rooms and was known for its hospitality and splendid cuisine. (Published by Souvenir Post Card Co., New York; postmarked 1910.)

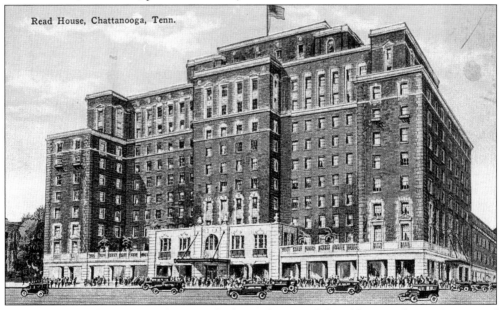

READ HOUSE. The new Read House, built on the site of the old, opened in 1926. It is of modified Georgian architecture, according to the plans of Holabird and Root, and cost $2,500,000. Twelve-stories tall, the building has 400 rooms and "is fireproof and modern in every detail." (Published by D.R. Weill, Chattanooga; postmarked 1928.)

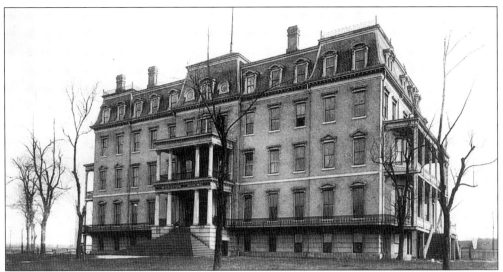

STANTON HOUSE. This historic hotel was built in 1870 at a cost of $200,000. Five-stories tall, it had 100 rooms and was advertised as "the most elegant hotel in the South." It was located five minutes from the depot and "furnished throughout with black walnut furniture at very great expense . . . parlors are spacious . . . dining room will seat 200 guests." It featured a billiard room, barroom, hairdressing department, telegraph office, and livery stable. The rates were $2.50 and $3 per day. Its advertisement further states that "Guests are carried to and from all trains FREE." The Stanton House was demolished in 1906 to make way for the Terminal Station. (Published by Rotograph, New York.)

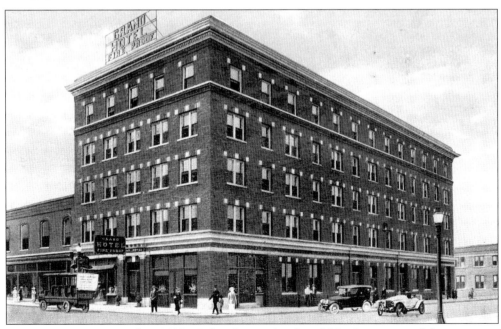

GRAND HOTEL. Located at 1401 Market Street, the Grand Hotel was part of the enormous revitalization that occurred around the new Terminal Station. Built in 1909, the brick building emphasized its fireproof structure both on the sign at the front door and on the sign atop the building. (Published by T.H. Payne, Chattanooga.)

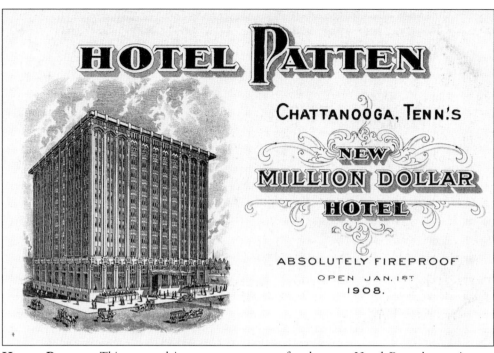

HOTEL PATTEN. This postcard is an announcement for the new Hotel Patten's opening on January 1, 1908. Evidence of its new "class" include the fact that it cost $1 million to build and that it is "absolutely fireproof." So many buildings met their demise by fire during these years that the public awareness of fireproof safety was at its peak. Rates were $1.50 and $2. (No publication data available.)

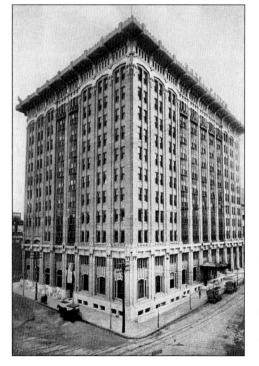

HOTEL PATTEN. The Patten, built in 1908, is shown here in its new splendor. Several vehicles parked at the curb indicate the date of this photograph to be very close to opening date. Located at the intersection of Georgia Avenue, Market, and Eleventh Streets, it is "overlooked by Nature's Roof-Garden, Lookout Mountain." (Published by Detroit Publishing Co.)

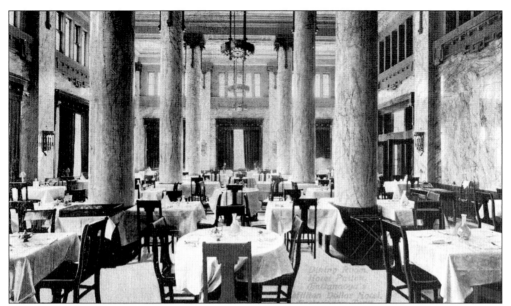

DINING ROOM, HOTEL PATTEN. CHATTANOOGA'S MILLION DOLLAR HOTEL. A most elegant dining room is shown here. The massive Classical columns and marble walls are complemented by the white tablecloths and the cut-glass decanters. (Published by CCCC.)

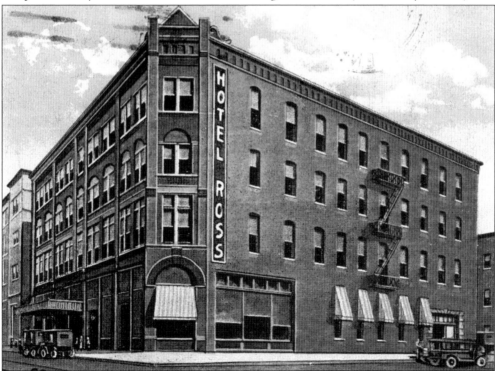

HOTEL ROSS. Located downtown, at the corner of Georgia Avenue and Market Street, the Ross is a triangular building with 70 rooms. This ad makes clear that automatic sprinklers would prevent patrons from perishing by fire: "In case of fire you may get WET but not BURNED." (Published by R.J. Shutting, Chattanooga; postmarked 1929.)

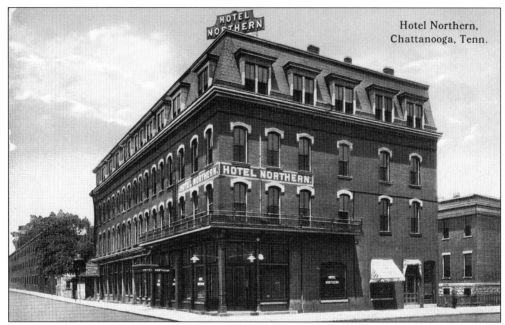

HOTEL NORTHERN. Advertised as "a recognized Silver Seal hotel by State Inspection Bureau," the Northern was centrally located on the West Eighth at Chestnut Street, in the heart of the business district. Its rates were $1.50 per day with private bath and $1 without bath. (Published by Knoxville Lithographing Co.)

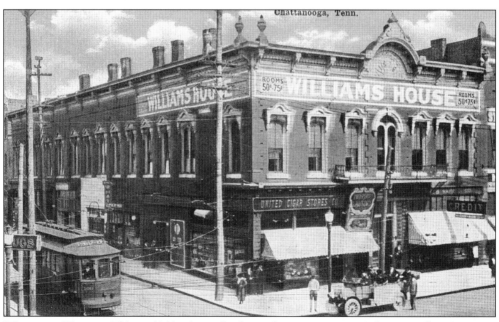

WILLIAMS HOUSE. This *c.* 1910 view of a busy downtown corner shows Williams House, located at Ninth and Market Streets. The prices on the sign indicate that rooms are 50¢ and 75¢, which means the hotel was not pretentious or luxurious. In fact, the second-story rooms are located just above the businesses on the ground floor. Transportation is nearby, however; a tour bus and a trolley await passengers. (Published by H.J. Deal, Chattanooga.)

GEORGIA AVENUE AND MARKET STREET. This *c.* 1905 postcard shows the Plaza Hotel as it first appeared in the triangle of Market, Tenth, and Georgia Streets. The Dome Building can be seen on the right. Note that the traffic consists of trolleys and horse-drawn carriages. (Published by Rotograph, New York.)

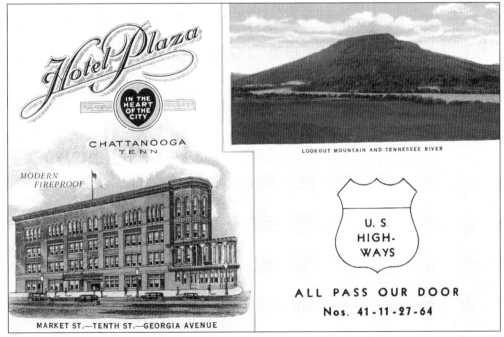

HOTEL PLAZA. A linen postcard from the 1930s shows the Plaza in a later incarnation, this time with a front extension. It advertises 100 rooms in its fireproof building and rates of $1.50 a day. (Published by Harry G. Brown, Chattanooga.)

HARKER'S TOURIST HOME
CHATTANOOGA, TENNESSEE

Phone 3-0834

"Away from all noise."

Locked Garages for all.

Running water in all rooms.

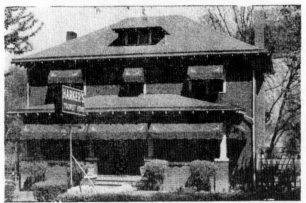

"A Home you will appreciate with rates you will like."

Large Porch

"One tells another."

4106 St. Elmo Avenue — Foot of Lookout Mountain

Four Blocks South of Highways No. 11--41--64

MEMBER "APPROVED FEDERAL HI-WAY TOURIST HOMES"

HARKER'S TOURIST HOME. With the Depression came Tourist Homes, many of which published advertising postcards. This 1930s card from Harker's Tourist Home enumerates its advantages: "Away from all noise . . . locked garages . . . running water . . . large porch." It was located at the foot of Lookout Mountain. (No publication data available.)

"ROOMS FOR TOURISTS." Mrs. Walter Benziger opened her 1805 McCallie Avenue home to tourists in the 1930s. She advertises a "Modern Brick Guest Home. Large rooms, all conveniences, furnace heat, free garage. Two blocks from Orchard Knob (General Grant's Headquarters) and 3 minutes from the heart of the city. Experienced Guide and Historian furnished upon request." (Published by Target Printing Co., Chattanooga.)

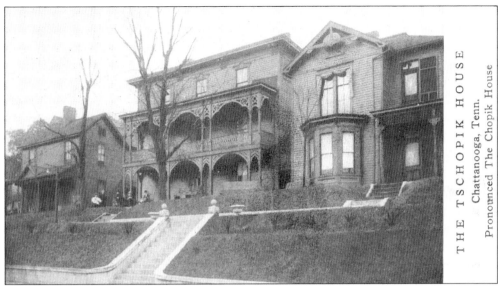

THE TSCHOPIK HOUSE
Chattanooga, Tenn.
Pronounced The Chopik House

THE TSCHOPIK HOUSE. Among the dwellings not readily defined either as homes or hotels is the Tschopik House, located at 512 Cherry Street. This attractive building with Victorian filigree on the porches is seen in the center of this postcard picture. In the City Directory of 1909, it is listed under "Boarding Houses." (Published by MacGowan-Cooke, Chattanooga.)

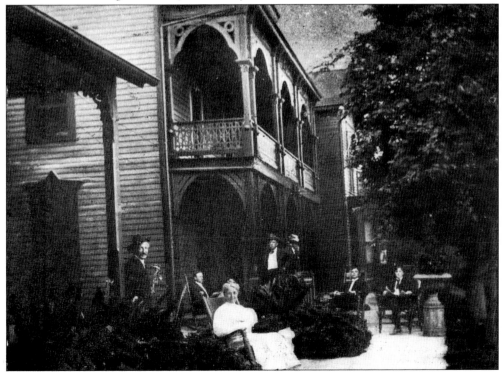

THE TSCHOPIK HOUSE. This pleasant group seen on the veranda seems to include all ages. The sender of the card writes: "Dear Mother, here is where I am stopping. Write me earlier in the week than you did when I was in North Carolina as it takes longer for a letter to reach me now. Best love, Your son Tom." (Published by MacGowan-Cooke, Chattanooga; postmarked 1909.)

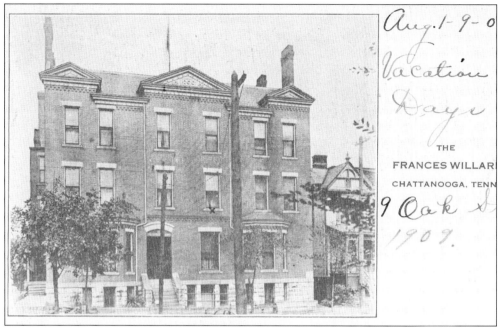

Handwritten on image: *Aug. 1-9-0 Vacation Days 9 Oak St 1909.*

THE
FRANCES WILLARD
CHATTANOOGA, TENN

THE FRANCES WILLARD. The Frances Willard Home, built in 1901, is located near the First Baptist Church at Nine Oak Street. The building was named in honor of educator and reformer Frances Willard (1839–1898), the founding motivator of the Women's Christian Temperance Union. The dorm-like living quarters provided a strictly supervised Christian homeplace for young women from rural areas who worked in the city. The present Frances Willard Building (located at 615 Lindsay Street) is an office building. (No publication data available.)

CHEROKEE TOURIST CAMP. Another phenomenon of the 1930s was the tourist camp. Cherokee Tourist Camp was located two miles north of Chattanooga on Dixie Highway at routes 27 and 29. The card informs us that the camp "is equipped with hot shower baths, rest rooms, grocery store, lunchroom, and cottages completely furnished." A room for two cost $1.50 per day; tent space cost 50¢. (Published by L.M. Mullenix, Lookout Mountain.)

ASHLAND FARM. This limited view shows the front veranda of the home of Zeboim Cartter Patten, located on Chattanooga Valley Road. One of the city's industrial magnates, Patten founded the Chattanooga Medicine Co., which made a huge success with its patent medicines Cardui and Black Draught. He also founded the Stone Fort Land Co. and the Volunteer State Life Insurance Co., and he was deeply involved in civic affairs. (Published by Asheville Post Card Co.)

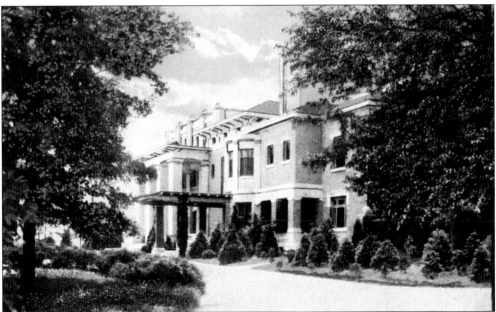

LYNDHURST—HOME OF J.T. LUPTON. In 1899, John Thomas Lupton, then a lawyer and treasurer of the Chattanooga Medicine Co., entered into the business of bottling Coca-Cola for national distribution. Chattanooga established the first franchised Coca-Cola bottling company and John T. Lupton became one of the country's richest men. His home, "Lyndhurst," which overlooked the Tennessee River, was considered one of the finest in the South. (Published by T.H. Payne, Chattanooga; postmarked 1923.)

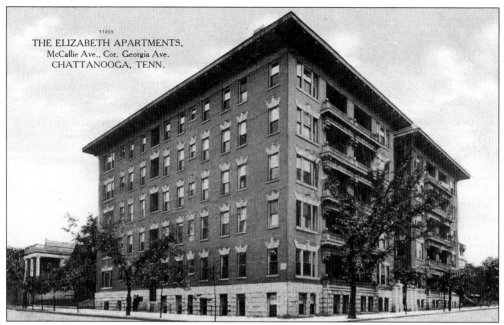

THE ELIZABETH APARTMENTS. Located near the downtown area, the Elizabeth Apartments appear to be a conservative and dignified place to live. The address is McCallie Avenue, at the corner of Georgia Avenue. (No publication data available; postmarked 1909.)

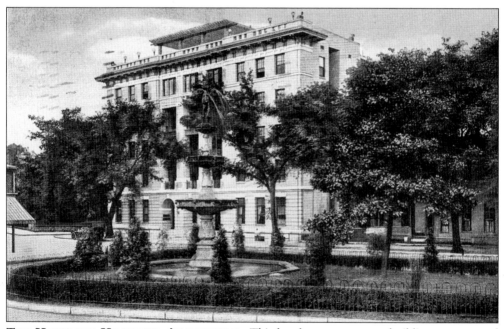

THE HARDWICK-HOGSHEAD APARTMENTS. This handsome apartment building, constructed in 1916, is located on the corner of Georgia Avenue and Vine Street (opposite Fountain Square). It houses professional offices on the lower floor and features a roof garden on top of the building. (Published by T.H. Payne, Chattanooga; postmarked 1917.)

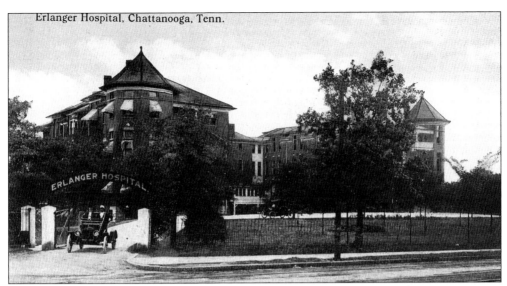

Erlanger Hospital, Chattanooga, Tenn.

ERLANGER HOSPITAL. Erlanger Hospital was named for the wife of Baron Emile Erlanger, a foreign investor in the Alabama and Chattanooga Railroad. The Baroness was a daughter of John Slidell, who represented the Confederate States in France. In 1889, inspired by his wife, Baron Erlanger made a sizable donation toward the building of a new hospital. It was immediately named for the Baroness. The facility opened in 1889 with eight patients. In its enormously expanded capacity, now located at East Third and Wiehl Streets, it is the nucleus of nearly a dozen related buildings. This postcard shows a 1910 view. (Published by S.H. Kress.)

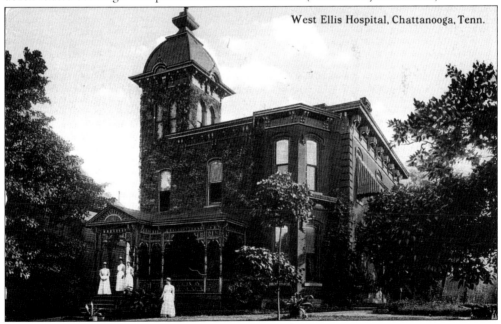

West Ellis Hospital, Chattanooga, Tenn.

WEST ELLIS HOSPITAL. Four primly-clad nurses stand in front of this Victorian brick building. The sender of this card gives the following news of her father: "This is a picture of the hospital where we have Father. He is still alive, the Drs. giving hopes one time and again discouraging us . . . he is out of his head . . . he is very weak . . . he hiccoughs most of the time." (Published by S.H. Kress; postmarked 1913.)

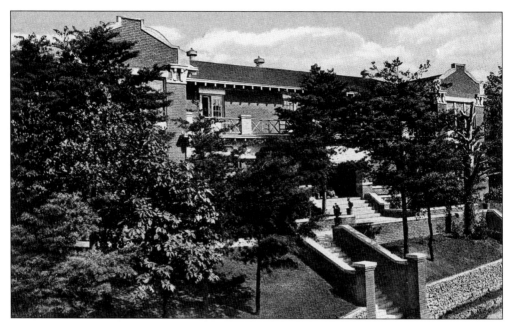

PINE BREEZE SANITARIUM. Founded in 1909, Pine Breeze Sanitarium is located on Hamilton Avenue (Pine Breeze Road) in North Chattanooga. (Published by T.H. Payne, Chattanooga.)

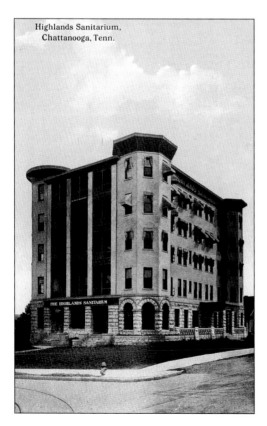

Highlands Sanitarium,
Chattanooga, Tenn.

HIGHLANDS SANITARIUM. An impressive building, Highlands Sanitarium contributed its medical facilities to the city of Chattanooga. At the time of this card, the building was located at McCallie and Fairview Streets. The facility's name is boldly inscribed on the front and on the side of the building. Look closely; the name Dr. W.G. Bogart can also be seen on the front. The sender of the card writes the following: "This is where I am spending most of my time. I am getting along fine." (Published by S.H. Kress; postmarked 1912.)

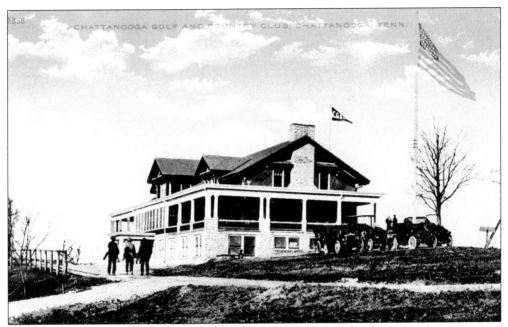

CHATTANOOGA GOLF AND COUNTRY CLUB. Early in the century, the Chattanooga Golf and Country Club (located on Riverview Road) looked like this. In later years, it was much enlarged and improved in appearance. The automobiles date the picture *c.* 1912. (Published by S.H. Kress.)

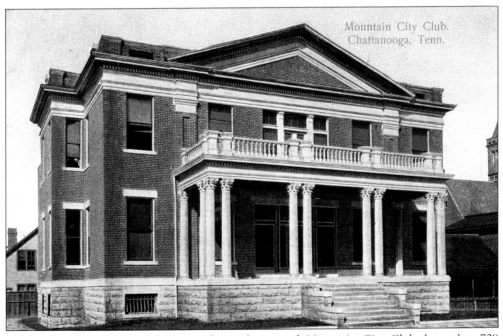

MOUNTAIN CITY CLUB. This view shows the second Mountain City Club, located at 729 Chestnut Street. The 1902 Gothic-style building at Eighth and Broad Streets was replaced by this Classical simplicity in 1912. (No publication data available.)

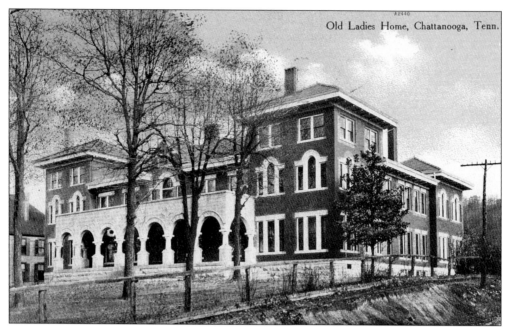

OLD LADIES HOME. Established in 1892 on Union Avenue, the Old Ladies Home moved to 714 Dodds Avenue in 1906 following a fund-raising campaign. The title has long since been considered inappropriate and derogatory; the facility is now called Oak Manor. (Published by S.H. Kress; postmarked 1909.)

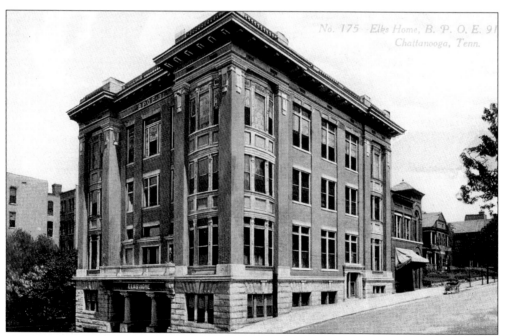

ELKS HOME, B.P.O.E. 91. Located at the corner of Walnut and Seventh Streets, the Benevolent and Protectorate Order of Elks occupied this impressive building. Its detail is Renaissance revival in design, ostensibly from the hand of a practiced architect. (Published by S.H. Kress.)

THIRD DISTRICT PUBLIC SCHOOL, SOUTH SIDE. An elegant, old school built with fort-like Romanesque embellishments, this building housed 1,000 students, according to the card's sender. Apparently the card was enclosed in an envelope—there was no postmark or stamp. The sender writes as follows: "This building is where our youngest children attend school." (No publication data available.)

HIGH SCHOOL, CHATTANOOGA, TN. Chattanooga High School, established in 1874, is Tennessee's oldest public secondary school. This building was the seventh site occupied by the school; its years of tenure were 1905–1921. The school was relocated to 413 East Eighth Street. In 1963, the school opened its latest and finest facility at 1331 Dallas Road. (No publication data available.)

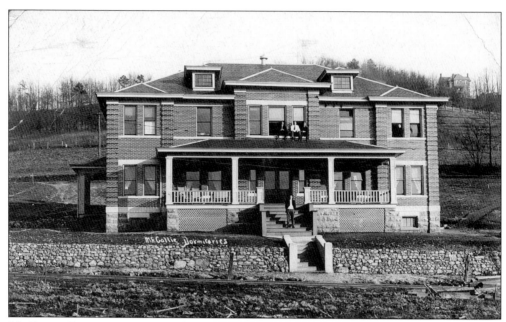

MCCALLIE DORMITORIES. McCallie School was founded in 1905 by Rev. T.H. McCallie, D.D., who served as a Presbyterian minister in Chattanooga for 50 years. The school now occupies 40 acres with more than 20 buildings and athletic facilities on the site. The first dormitory was built in 1907; the house in the picture might well have been the one. (Real Photo.)

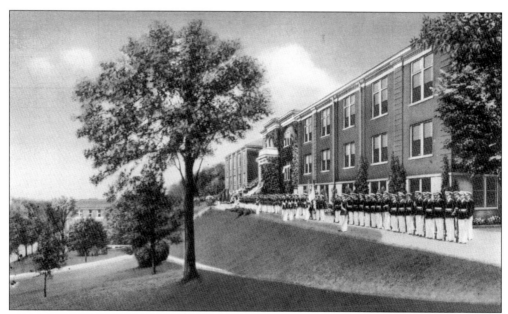

THE MCCALLIE SCHOOL CAMPUS. This 1930s card shows the McCallie cadets lined up for a drill. The school became semi-military in 1918; the instruction was much the same as that of the Junior ROTC program. This program, along with McCallie's reputation for academic excellence, has enhanced its standing among preparatory schools in the nation to the highest level. (Published by T.H. Payne, Chattanooga.)

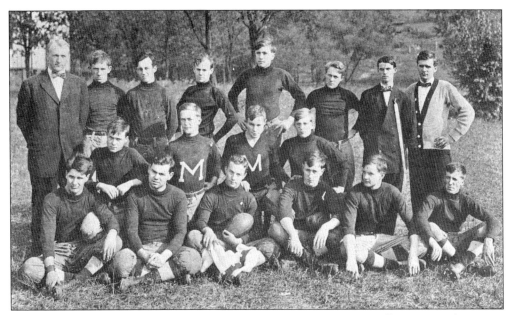

MᴄCᴀʟʟɪᴇ 1908 Pʀᴇᴘ. Cʜᴀᴍᴘɪᴏɴs ᴏғ Eᴀsᴛ Tᴇɴɴᴇssᴇᴇ. Occasionally, a postcard turns up with a very special picture. Pictured are McCallie football players, looking very serious and older than teenagers usually look. We have no identification for them—perhaps their grandchildren do. (No publication data available.)

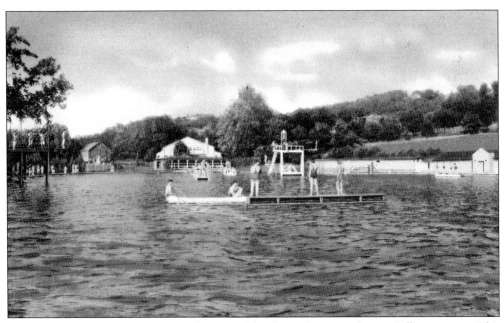

Tʜᴇ MᴄCᴀʟʟɪᴇ Sᴄʜᴏᴏʟ Lᴀᴋᴇ. There is a lake for students on the McCallie property. This early card cannot reflect the improvements made since that time; an indoor pool was also added in 1960. The Christian purpose of the school is behind all its activities. Its motto is "Man's chief end is to glorify God and enjoy Him forever." (Published by T.H. Payne, Chattanooga.)

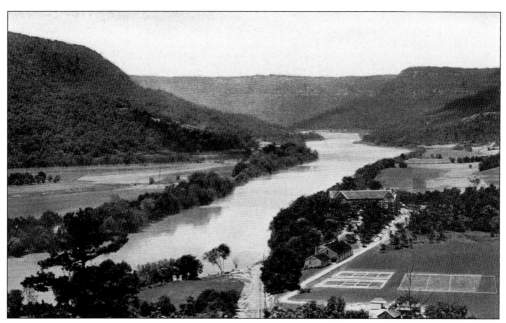

THE BAYLOR SCHOOL. The Baylor School for boys was founded in 1893 and enjoys a splendid location on the north side of the Tennessee River (east of Williams Island). In this view, it is surrounded by most of the great vistas of "The Grand Canyon of Tennessee." (Published by T.H. Payne, Chattanooga.)

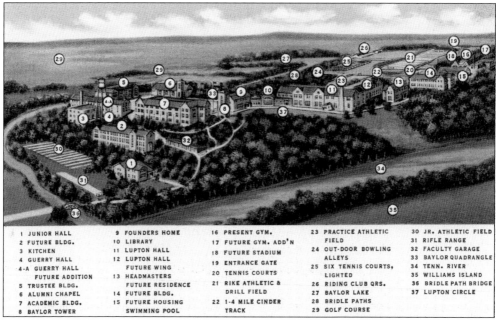

1 JUNIOR HALL	9 FOUNDERS HOME	16 PRESENT GYM.	23 PRACTICE ATHLETIC	30 JR. ATHLETIC FIELD
2 FUTURE BLDG.	10 LIBRARY	17 FUTURE GYM. ADD'N	FIELD	31 RIFLE RANGE
3 KITCHEN	11 LUPTON HALL	18 FUTURE STADIUM	24 OUT-DOOR BOWLING	32 FACULTY GARAGE
4 GUERRY HALL	12 LUPTON HALL	19 ENTRANCE GATE	ALLEYS	33 BAYLOR QUADRANGLE
4-A GUERRY HALL	FUTURE WING	20 TENNIS COURTS	25 SIX TENNIS COURTS,	34 TENN. RIVER
FUTURE ADDITION	13 HEADMASTERS	21 RIKE ATHLETIC &	LIGHTED	35 WILLIAMS ISLAND
5 TRUSTEE BLDG.	FUTURE RESIDENCE	DRILL FIELD	26 RIDING CLUB QRS.	36 BRIDLE PATH BRIDGE
6 ALUMNI CHAPEL	14 FUTURE BLDG.	22 1-4 MILE CINDER	27 BAYLOR LAKE	37 LUPTON CIRCLE
7 ACADEMIC BLDG.	15 FUTURE HOUSING	TRACK	28 BRIDLE PATHS	
8 BAYLOR TOWER	SWIMMING POOL		29 GOLF COURSE	

THE BAYLOR SCHOOL "ALONG THE CHEROKEE TRAIL." A directive postcard from the 1930s pin-points the many buildings and facilities of Baylor School. A prestigious school with a long history, Baylor stands with the finest U.S. preparatory schools in academic performance. (Published by T.H. Payne, Chattanooga.)

THE BAYLOR SCHOOL FOR BOYS. One of the important buildings on the Baylor campus is the Founders Home (left). It is used as the masters' quarters. The Baylor Library is in the foreground. (No publication data available.)

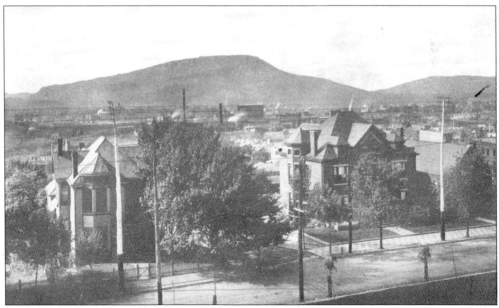

LOOKOUT MOUNTAIN FROM GRANT UNIVERSITY. This postcard is a view from Grant University. After several complicated moves between Athens and Chattanooga, Grant University consolidated in 1911 to become the University of Chattanooga. It is located on McCallie Avenue between Douglas and Baldwin Streets. (No publication data available.)

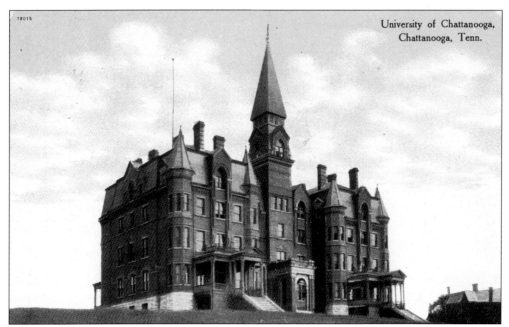

UNIVERSITY OF CHATTANOOGA. University Hall, or "Old Main," at one time housed the entire university on McCallie Avenue. It contained the classrooms, dorm rooms, library, faculty apartments, offices, kitchen, mess hall, and chapel. It was torn down in 1917 to make way for many new buildings. (No publication data available; postmarked 1909.)

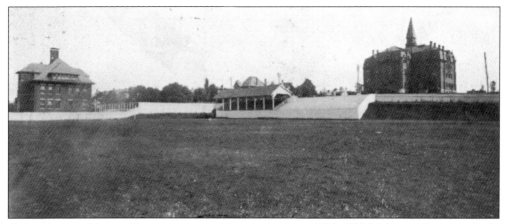

CHAMBERLAIN FIELD, UNIVERSITY OF CHATTANOOGA. With Old Main standing proudly in the background, and with only one other college building (left), this view shows the broad expanse of Chamberlain Field *c.* 1909. The field is located behind the main quadrangle. Built in 1908, it was named for Capt. Hiram S. Chamberlain, president of the university's board of trustees. (No publication data available; postmarked 1909.)

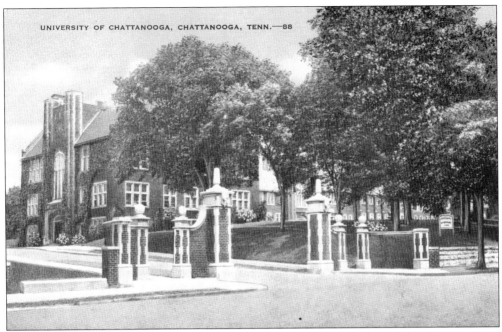

UNIVERSITY OF CHATTANOOGA. Pictured are the main gates opening to the campus from McCallie Avenue. The vehicle access is located between the quadrangle buildings and the library, which is not pictured. (Published by Chattanooga Magazine Co.)

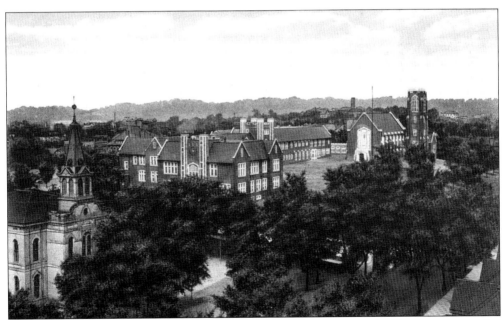

CAMPUS QUADRANGLE, UNIVERSITY OF CHATTANOOGA. The main buildings on campus that form the quadrangle were designed in Tudor Gothic style by H.B. Downing. This early postcard picture shows a church (left) that evidently pre-dated the library building. (Published by T.H. Payne, Chattanooga.)

71

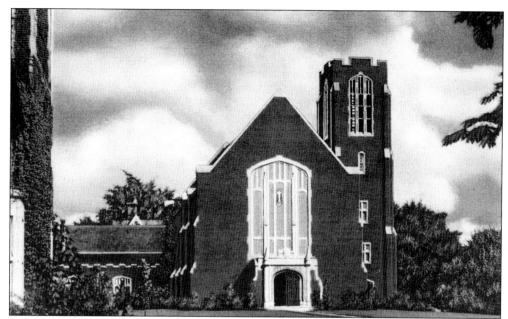

JOHN A. PATTEN MEMORIAL CHAPEL. Dominating the quadrangle of the University of Chattanooga, the chapel carries out the Tudor Gothic design of the main buildings. John A. Patten was a managing officer of the Chattanooga Medicine Co. and was a dominant supporter of river commerce and development at the turn of the century. (Published by Curt Teich, Chicago.)

THE UNIVERSITY OF CHATTANOOGA QUADRANGLE, WINTER. A snowfall blankets the quadrangle in this rare scene of the university buildings. In 1969, the University of Chattanooga became a part of the University of Tennessee system. (No publication data available.)

Four

CHATTANOOGA STREETS

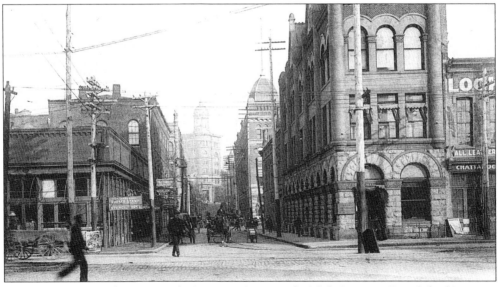

EIGHTH STREET. This is an early (pre-1906) view of Eighth Street at Broad, looking east. Loveman's (with cupola) is seen one block away; on the left are various small businesses, including a beer establishment, a real estate office, and the Chattanooga Rubber Stamp and Stencil Works. Transportation on the street is quite primitive. (Published by Rotograph, New York.)

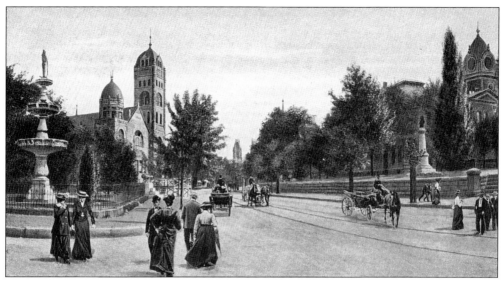

FOUNTAIN SQUARE. Located at the intersection of Lookout Street, Georgia Avenue, and East Sixth Street, Fountain Square contains several landmarks of Chattanooga history. On the left is the Fireman's Fountain, the area's namesake. It was erected in 1887 in memory of two firemen who died in the Bee Hive Store fire the previous year. In the distance is the First Baptist Church (left), and the old courthouse (right) that burned in 1910. The picture dates from 1905. (Published by Raphael Tuck and Sons, London; series 2176.)

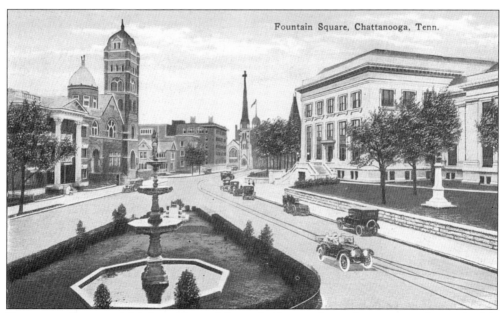

FOUNTAIN SQUARE. This later view of Fountain Square shows the new courthouse (right), which was erected in 1912. A statue of a fully equipped fireman can be seen at the top of the Fireman's Memorial Fountain. The First Methodist Church and the golden dome of the Times Building can be seen in the distance (Published by D.R. Weill, Chattanooga.)

MARKET AND EIGHTH STREETS—TIMES BUILDING. This early street scene shows the landmark Times Building in the distance. In the foreground (right) is D.B. Loveman's department store, built in 1889. Its identifying cupola was later removed. A horse-drawn trolley can be seen on the right. Ladies' skirts still sweep the streets. (Published by S.H. Kress; postmarked 1909.)

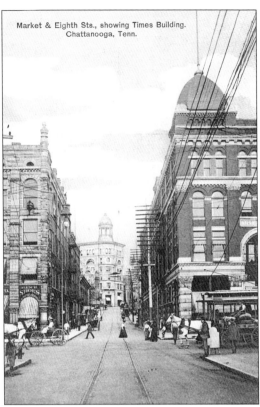

Market & Eighth Sts., showing Times Building. Chattanooga, Tenn.

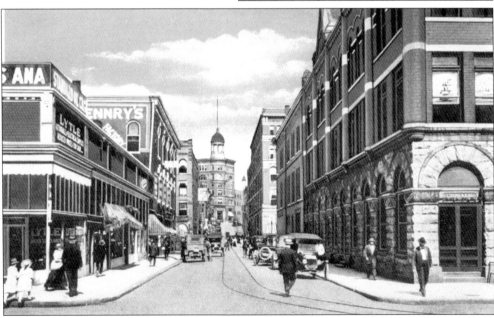

EIGHTH STREET. By 1912, Eighth Street (at Broad) has changed; most notable are the automobiles and the renovation of the buildings on the left. The massive building (right) houses law offices, according to the signs on the upper windows. Loveman's is seen in the center at the next corner, without its cupola. (Published by T.H. Payne, Chattanooga.)

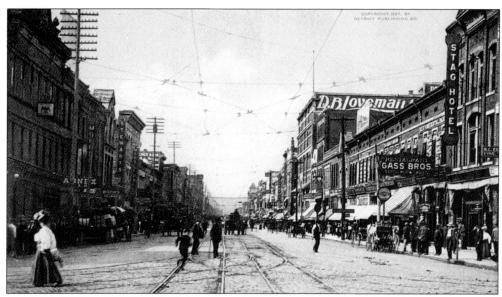

MARKET STREET. The busy life of Market Street, the commercial center of the city, is reflected in this *c.* 1903 view. The street is paved with stone blocks, and many businesses line the curbs. D.B. Loveman's cannot be overlooked. Also pictured is Gass Bros. Restaurant, located at 832 Market, and the Stag Hotel. Traffic was light enough that people could walk in the streets without hindrance. (Published by Detroit Publishing Co.)

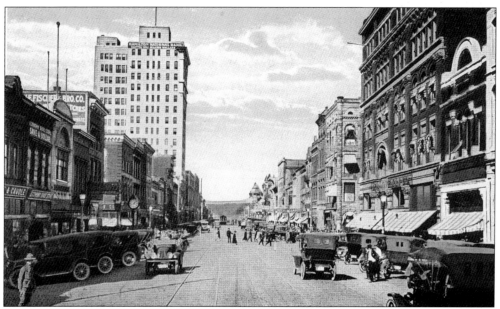

MARKET STREET. In this *c.* 1918 view, looking down Market Street toward Seventh Street, the Hamilton Bank Building is seen in the distance (left) and Loveman's store is visible (right foreground). Note the soldier in uniform. (Published by E.C. Kropp, Milwaukee.)

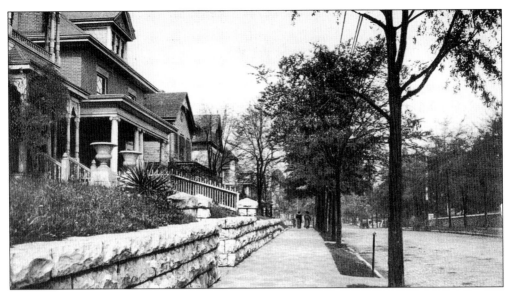

MCCALLIE AVENUE. An important street spanning the city from Missionary Ridge west to Georgia Avenue, McCallie Avenue reflects the name of a prestigious Chattanooga family and its school. In the early 1900s, many Victorian homes were located here. Olympia Park and Grant University (the present-day University of Tennessee at Chattanooga) were also located on this street. (Published by Detroit Publishing Co.)

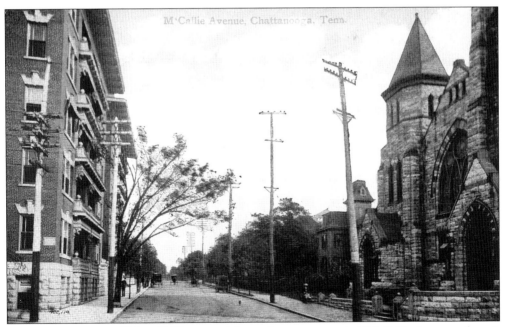

MCCALLIE AVENUE. This *c.* 1905 postcard shows the western end of McCallie Avenue where it meets Georgia Avenue. Seen on the left is the Elizabeth Apartments building, and on the right is a portion of the First Methodist Church. The street shows only horse-drawn transportation. (Published by L.J. Pettus, Chattanooga.)

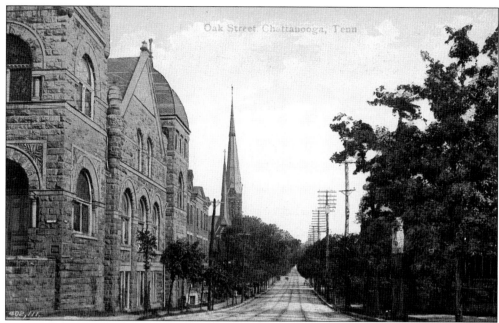

OAK STREET. Oak and Vine Streets run parallel to McCallie Avenue for many blocks. In the several blocks between Warner Park and Georgia Avenue, including the Fort Wood district, there are a number of historic houses. In this view of the corner of Oak Street and Georgia Avenue is a portion of the First Baptist Church (left foreground); the steeple of the First Cumberland Presbyterian Church can be seen in the distance. (Published by L.J. Pettus, Chattanooga.)

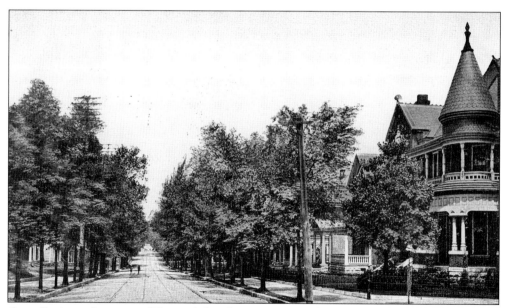

OAK STREET, LOOKING WEST. A handsome Victorian home dominates the scene in this picture. Most houses built in this area date from 1880–1920, with Queen Anne, Romanesque, and Classical styles predominating. (Published by Souvenir Post Card Co., New York. Postmarked 1908.)

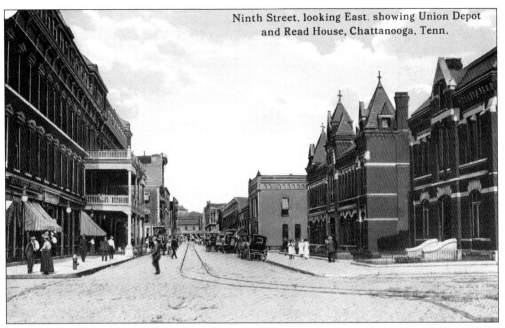

NINTH STREET, LOOKING EAST. This busy, downtown scene shows the old Read House (left). It was located at this site 1872–1926. Also pictured is the Union Depot, which was built in 1858 and demolished in 1973. Until 1926, Broad Street dead-ended at Ninth Street. (Published by S.H. Kress.)

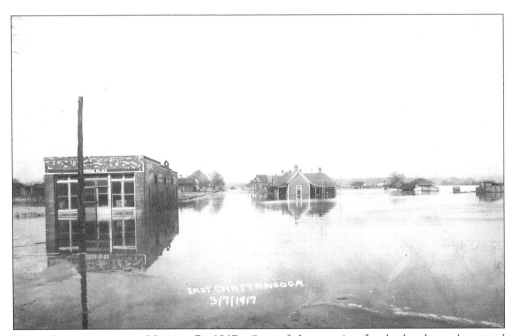

EAST CHATTANOOGA—MARCH 7, 1917. One of three major floods that have devastated Chattanooga (the earlier ones were 1867 and 1875), the flood of March 1917 is pictured here. The waters rose high enough to reach the 300 block of Main Street and inundated countless homes and businesses. (Real photo.)

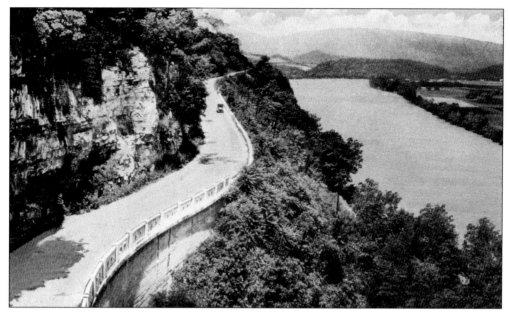

HIGHWAY UP LOOKOUT MOUNTAIN. Going to the top of Lookout Mountain by automobile is an adventurous and edifying experience. The well-constructed highway parallels the river for several miles, giving passengers outstanding views of the countryside. (Published by C.T. Lloyd, Lookout Mountain.)

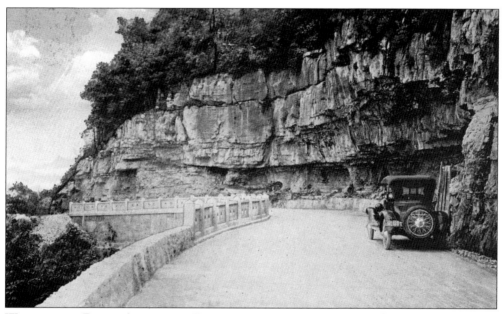

WAUHATCHIE ROAD, ALONG THE EDGE OF LOOKOUT MOUNTAIN. This road to the summit leads to Ruby Falls and Point Park, two major tourist attractions in the area. The drive from Chattanooga to the top of the mountain takes about 15 minutes. From the top one can see five states on a clear day. (Published by L.M. Mullenix, Lookout Mountain.)

Five

PARKS, RECREATION, AND ACTIVITIES

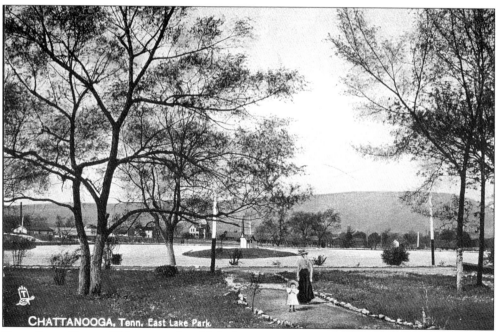

CHATTANOOGA, Tenn. East Lake Park.

EAST LAKE PARK. This postcard, published in 1907, bears the following information on the back: "East Lake Park, about 20 minutes from the city on the electric cars, is a most attractive spot around East Lake, a pretty little body of water formed from a spring at the foot of Missionary Ridge, where the great battle of November 25, 1863, was fought. An interesting zoo is maintained in the park." (Published by Raphael Tuck and Sons, London; series 2587.)

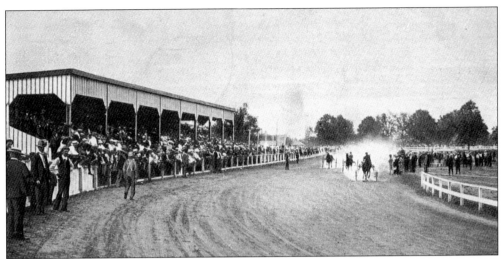

OLYMPIA PARK RACE TRACK. The information on the card reads as follows: "Olympia Park is a beautiful spot located on McCallie Avenue, midway between the city and Missionary Ridge. It is owned and operated by the Chattanooga Street Railways Co., and included in its limits is a fine half-mile race course." (Published by Raphael Tuck and Sons, London; series 2463; postmarked 1907.)

WARNER PARK. The old Olympia Park was bought in 1912 by the City of Chattanooga and was renamed Warner Park. It claimed to be "the largest municipal playground in the United States equipped with complete playground equipment." In addition to the race track, the park included four baseball diamonds, ten tennis courts, a merry-go-round, and "a modern Comfort Station, one of the first established in the South." Other conveniences offered were two refreshment pavilions, a dancing pavilion, bandstands, and picnic grounds. The minimal view on the card does not show these advantages. (Published by T.H. Payne, Chattanooga.)

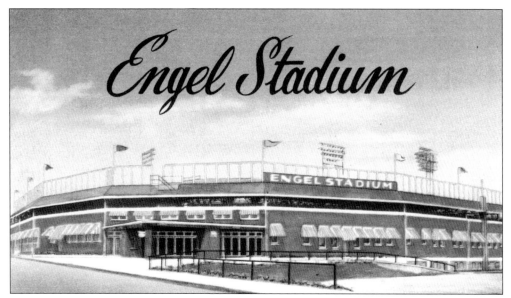

ENGEL STADIUM. Built in 1929, and named for Joe Engel, "The Barnum of Baseball," Engel Stadium seated 12,000 fans and was the home of the Lookouts baseball team. Joe Engel's outlandish promotions increased attendance at the ball park from 78,000 to 172,000 in his first year as president of the club. (Published by National Press, Chicago.)

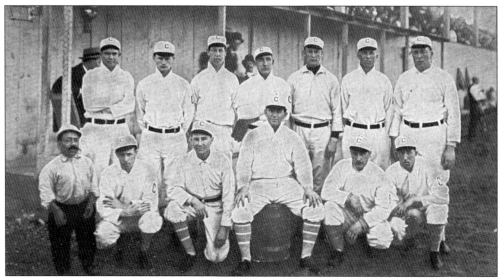

CHATTANOOGA BASEBALL TEAM. The name "Chattanooga Lookouts" was first used in 1909 when the team became champions of the South Atlantic League. The team won another championship in 1932, after a number of years with the Southern Association. Several famous players have played at Chattanooga, including Rogers Hornsby and Herman Killibrew. Satchel Paige and Willie Mays played with black teams here. (Published by Rollins and Hardison, Lookout Mountain.)

83

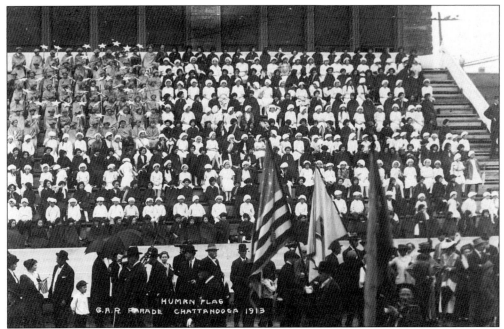

HUMAN FLAG, GRAND ARMY OF THE REPUBLIC (GAR) PARADE. This patriotic community activity—making a human flag—was performed in September 1913 to commemorate the 50th anniversary of the Battle of Chickamauga. Seen here, assembled on bleachers, the group seems to be mostly comprised of children. GAR reunions and parades were of great importance during the early 1900s. (Published by W.M. Cline, Chattanooga; postmarked 1913.)

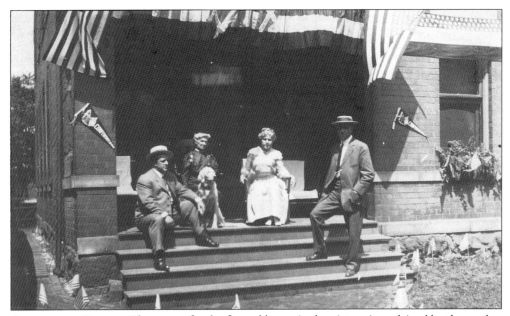

GROUP ON A PORCH. The reason for the flagged house in the picture is explained by the sender: "This is the house as it was decorated for Confederate reunion and will be for GAR. That is Harry standing on the steps. I hope it will be cooler by that time, but Sept. is a hot time down here." (No publication data available; postmarked 1913.)

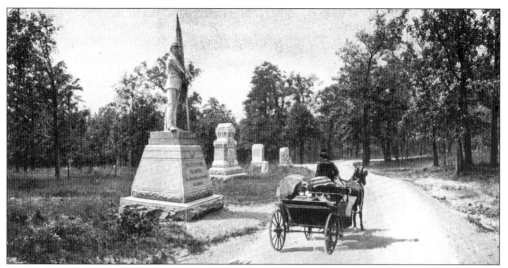

SCENE IN THE KELLY FIELD, CHICKAMAUGA PARK. Chickamauga Park is a federal reservation that includes Lookout Mountain, Missionary Ridge, and Orchard Knob. During the Battle of Chickamauga in September 1863, the Federal Army of the Cumberland under Gen. William S. Rosecrans was defeated by the Confederate Army of Tennessee under Gen. Braxton Bragg. After the battle, Lookout Mountain was occupied by Confederate troops; however, in November 1863, the tide was turned and the Union Army was victorious. (Published by Raphael Tuck and Sons, London; series 2176.)

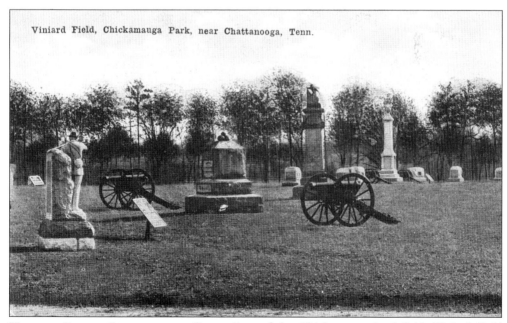

Viniard Field, Chickamauga Park, near Chattanooga, Tenn.

VINIARD FIELD, CHICKAMAUGA PARK. Part of the Chickamauga battlefield, Viniard Field contains many monuments indicating the various regiments that took part in the fierce fighting of September 19–20, 1863. The park was established in 1895. (No publication data available.)

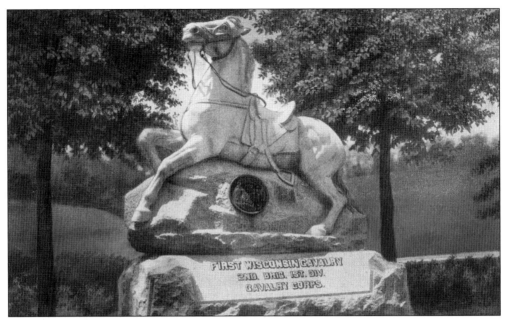

WISCONSIN MONUMENT, "RIDERLESS HORSE," CHICKAMAUGA PARK. The Riderless Horse Monument in Viniard Field, Chickamauga Park, always attracts attention. It commemorates the First Wisconsin Cavalry, 2nd Brigade, 1st Division, which fought here. (Published by T.H. Payne, Chattanooga.)

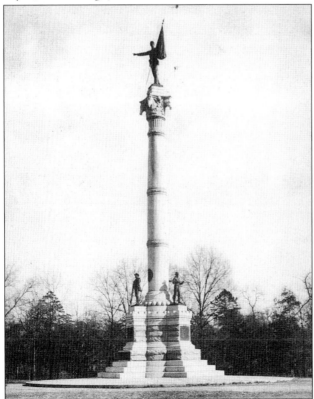

CONFEDERATE MONUMENT, CHICKAMAUGA PARK. This marble shaft, mounted on a pedestal with three uniformed soldiers, commemorates the thousands of Confederates who died at Chickamauga. The figure at the top with the flag is especially impressive. The Confederates sustained over 18,000 casualties here. (Published by Rotograph, New York.)

WILDER'S TOWER, CHICKAMAUGA. The tower marks the site of Widow Glenn's cabin, General Rosecrans's headquarters on Wilder Hill. The cabin burned September 20, 1863. On this day, Rosecrans's Union troops suffered over 16,000 casualties and lost about 28% of their strength. (Published by Detroit Publishing Co.)

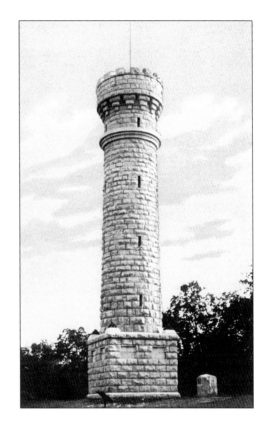

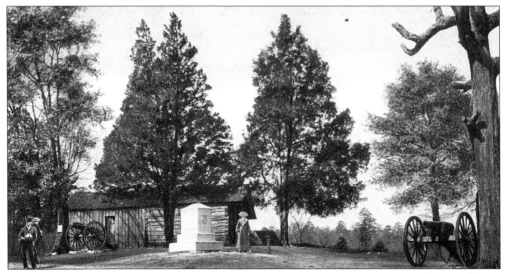

SNODGRASS HOUSE, CHICKAMAUGA PARK. This wooden cabin, located on Snodgrass Hill, was the site of Union Gen. George H. Thomas's headquarters during his heroic defense of this position on September 20, 1863. In spite of great difficulty, he drove back wave after wave of Confederate attacks until nightfall, when he withdrew. He became known as "The Rock of Chickamauga." (Published by Raphael Tuck and Sons, London; series 2463.)

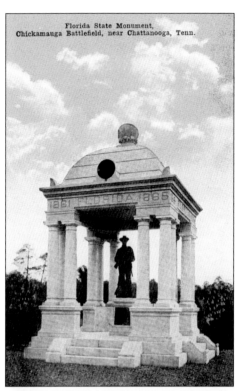

Florida State Monument,
Chickamauga Battlefield, near Chattanooga, Tenn.

FLORIDA STATE MONUMENT, CHICKAMAUGA PARK. The Florida monument on Chickamauga Battlefield is an unusual columned structure with a soldier protected beneath its roof. There are more than 1,400 monuments in Chickamauga Park. (Published by Read House Cigar Co., Chattanooga.)

LAKE WINNEPESAUKAH. Located 7 miles from the heart of Chattanooga, Lake Winnepesaukah is a 10-acre lake fed by 35 springs furnishing pure spring water to swimmers and boaters. Open since the mid-1920s, the entire facility includes a sand beach, handball court, tennis courts, shooting gallery, modern brick bathhouse and club room, large picnic grove, and concession stand that serves sandwiches and drinks. Its total size is 65 acres. (No publication data available.)

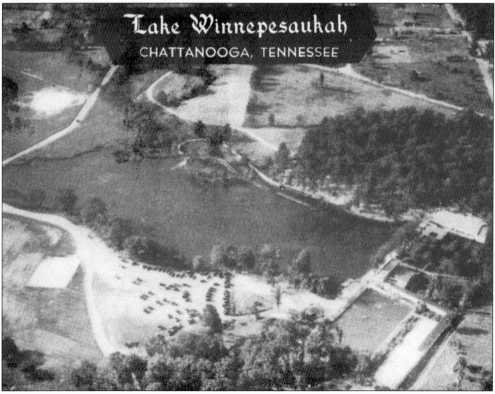

Lake Winnepesaukah
CHATTANOOGA, TENNESSEE

Six

LOOKOUT MOUNTAIN

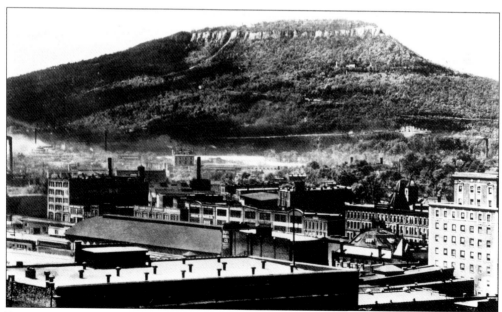

LOOKOUT MOUNTAIN FROM CHATTANOOGA. When in Chattanooga, one sees Lookout Mountain rising sharply on the southwest side of the city. From its peak, Point Lookout, 1,400 feet above the Tennessee river, early settlers were warned against the Native Americans. After the battle of Chickamauga, Lookout Mountain was occupied by Confederate troops; the "Battle of the Clouds" was fought here November 24, 1863, when the Union Army regained control. It was one of the most significant battles of the Civil War. (Real photo.)

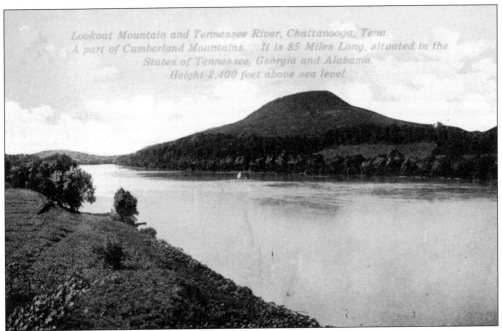

LOOKOUT MOUNTAIN AND THE TENNESSEE RIVER. This postcard is generous with statistics printed on the picture. This is the vista printed most often—the signature of Chattanooga country. (Published by W.H. Hardison, Chattanooga.)

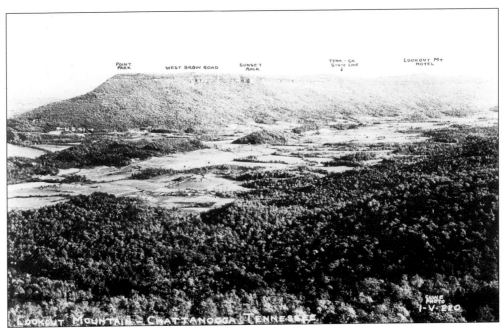

LOOKOUT MOUNTAIN. This view, taken from the west side of the mountain, shows the locations of some principal tourist objectives: Point Park (north end), Sunset Rock, and Lookout Mountain Hotel, to the south. (Real photo.)

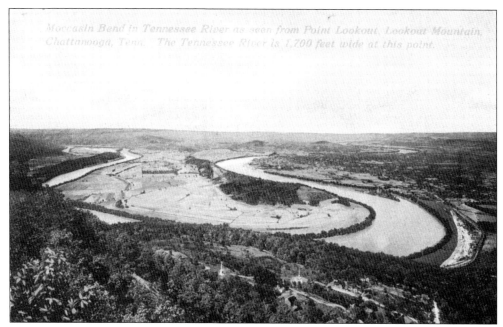

Moccasin Bend in Tennessee River as seen from Point Lookout, Lookout Mountain, Chattanooga, Tenn. The Tennessee River is 1,700 feet wide at this point.

MOCCASIN BEND IN TENNESSEE RIVER AS SEEN FROM POINT LOOKOUT. Looking down from Point Lookout, one sees the extraordinary Moccasin Bend formed by the Tennessee River as it makes a 7-mile curve, first turning south, then reversing itself around a peninsula that resembles a huge shoe. Hundreds of skeletons, found in a seated position, have been excavated on the peninsula. (Published by CCCC.)

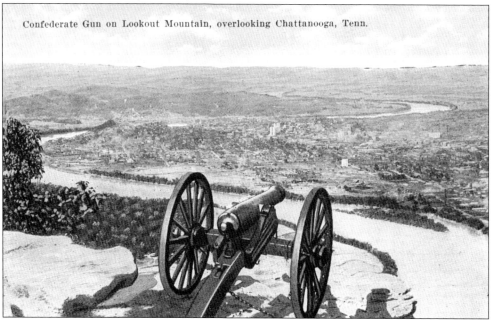

Confederate Gun on Lookout Mountain, overlooking Chattanooga, Tenn.

CONFEDERATE GUN ON LOOKOUT MOUNTAIN. From this remarkable position, the Confederates were routed by the Federals during the "Battle above the Clouds." The battle was fought on the north end of the mountain, where it tapers down toward the river. (Published by D.R. Weill, Chattanooga.)

POINT LOOKOUT. The Confederates were stationed here, in position to watch the movements of the Federals down below. Under the cover of heavy fog, Union Gen. Joseph Hooker and his men took the Confederates by surprise. (Published by L.M. Mullenix, Lookout Mountain.)

PULPIT ROCK, LOOKOUT MOUNTAIN. Many unusual rock formations like this one can be found on Lookout Mountain. It has been easy to give them characteristic names. (Published by Rotograph, New York.)

SUNSET ROCK, LOOKOUT MOUNTAIN.
When seen from below, Sunset Rock looks
very much like a face. "The Face" is a rock
formation 1,200 feet above, on the edge of a
ridge; it measures 35 feet from brow to chin.
According to legend, the rock resembles an
elderly Native American chief who prayed to
be remembered. (Published by Detroit
Publishing Co.)

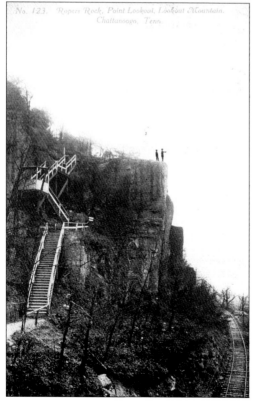

**ROPER'S ROCK, POINT LOOKOUT,
LOOKOUT MOUNTAIN.** This rock received
its name from a corporal of a Pennsylvania
regiment who fell from it and was killed.
The steps indicate the path of the Union
troops who scaled the mountain at this point.
(Published by S.H. Kress; postmarked 1911.)

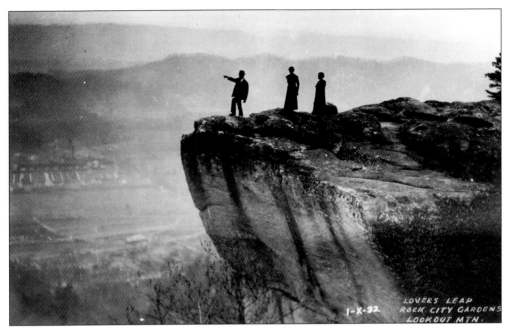

LOVERS' LEAP, ROCK CITY GARDENS, LOOKOUT MOUNTAIN. Rock City is a natural accumulation of rocks and caves covering 10 acres of the mountain. It ranks among the world's natural scenic wonders. Lovers' Leap, shown here before protective walls were constructed, provides a spectacular view. (Real Photo.)

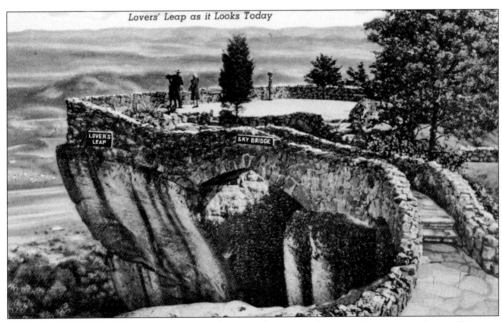

LOVERS' LEAP. When Rock City was developed as a tourist attraction, protective walls were built to blockade dangerous areas. This wall was built in 1940. The developers of the attraction, Garnet and Frieda Carter, also initiated the "See Rock City" signs. Seen all over the South, the signs were mostly painted on sides and rooftops of barns. (No publication data available.)

94

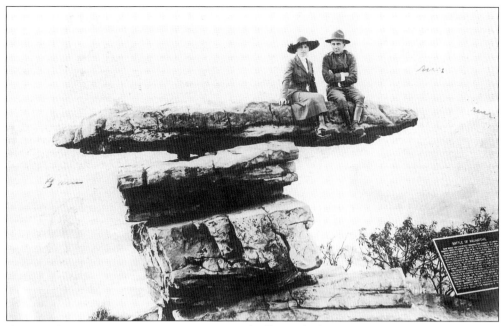

COUPLE SITTING ON UMBRELLA ROCK. Umbrella Rock, located on Point Lookout, is about 12 feet high and consists of several large stones topped by a large flat slab. Tourists have always liked to perch here to view the valley below. The sender of this card writes the following: "This picture cannot describe to you the beauty of the scenery . . . no card I have found does it justice." The soldier was probably on leave. (Real Photo; postmarked 1918.)

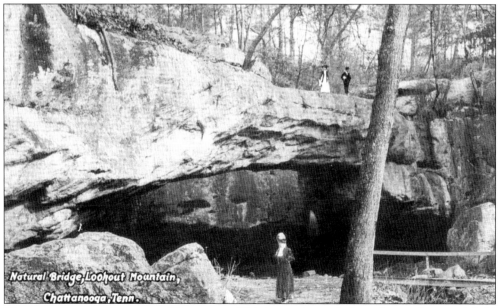

NATURAL BRIDGE, LOOKOUT MOUNTAIN. This impressive rock formation, aptly named, is 60 feet long and 15 feet high. After the Civil War, a hotel was built nearby and served many tourists to the area, especially a religious group called The Southern Association of Spiritualists. When the spiritualists left, the area declined. Natural Bridge Park is now very quiet. (Published by S.H. Kress; postmarked 1911.)

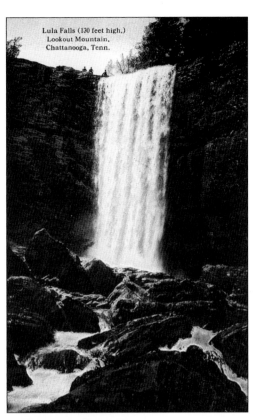

Lula Falls (130 feet high.)
Lookout Mountain,
Chattanooga, Tenn.

LULA FALLS, LOOKOUT MOUNTAIN.

Among Nature's scenic wonders, Lula Falls is a favorite spot for sightseers on Lookout Mountain. Named for Princess Telulah of the Cherokee Indians, the name was eventually shortened to Lula. According to legend, the Princess plunged to her death over the falls when her father refused to allow her to marry her lover. (Published by S.H. Kress.)

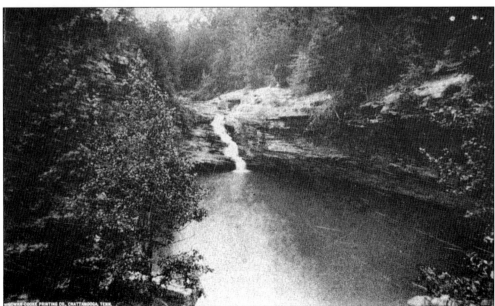

LULA LAKE, LOOKOUT MOUNTAIN. Lula Lake, a quiet, secluded spot, is another favorite tourist objective on Lookout Mountain. In the 1890s, plans were initiated to make Lula Falls and Lula Lake into a resort area; the plans were never carried out. The area remains fairly undeveloped. (Published by MacGowan-Cooke, Chattanooga; postmarked 1910.)

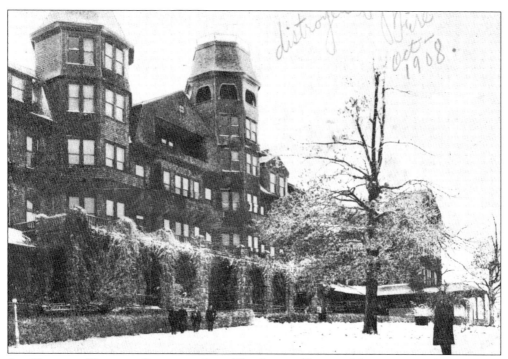

AN UNUSUAL VIEW AT LOOKOUT INN. The "unusual" part of the picture is the snow; the picture was taken November 15, 1906. Lookout Mountain Inn was built in the mid-1800s and was advertised as "the largest hotel of its kind in the South." It was enormously popular, partly because it was located at the top of the incline railway that was built in 1887. (Published by MacGowan and Cooke, Chattanooga.)

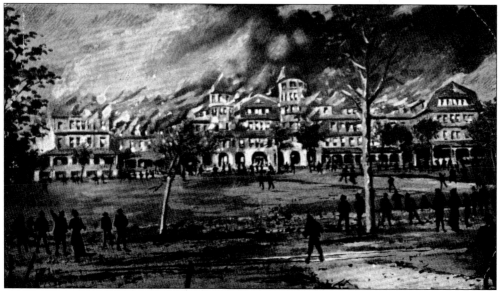

BURNING OF LOOKOUT INN. This luxury hotel was built at a cost of $250,000. It went up in flames November 17, 1908, in one of the most disastrous fires ever to occur in the Chattanooga area. This vivid postcard interpretation of the event was published immediately afterward. (Published by MacGowan-Cooke, Chattanooga; postmarked 1909.)

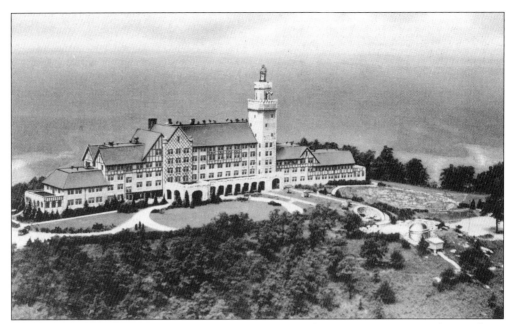

LOOKOUT MOUNTAIN HOTEL. This luxury hotel opened in June 1928. It was advertised as a "super structure of concrete and steel whose beacon light reflects throughout Dixie." It contained 200 rooms with baths, "each commanding a panorama of scenery unequaled anywhere. A homelike atmosphere prevails with every form of outdoor diversion carefully planned." Rates were $5 per day, including meals. (Published by Reynolds Co., Dayton, Ohio.)

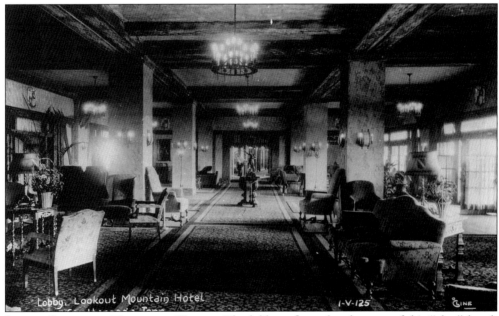

LOBBY, LOOKOUT MOUNTAIN HOTEL. The lobby reflects the elegance of this "class" hotel. The sender of the card writes as follows: "I had dinner at this hotel last Sunday and it's about the most beautiful I've ever seen. The view is wonderful and you can see for miles." The hotel was purchased by Covenant College of St. Louis in 1964; its four-year liberal arts program offers a "Christ-centered education." (Real Photo. Postmarked 1944.)

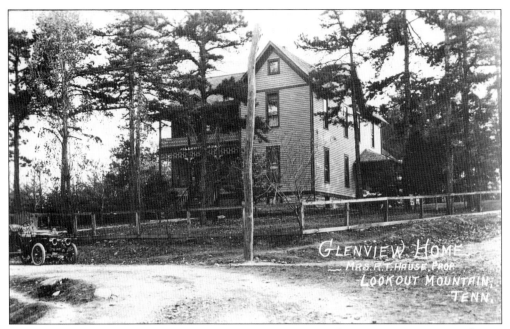

GLENVIEW HOME, LOOKOUT MOUNTAIN. Some tourists prefer more rustic accommodations than those provided by "class" hotels. The automobile parked in front dates the view *c.* 1920. (Real Photo.)

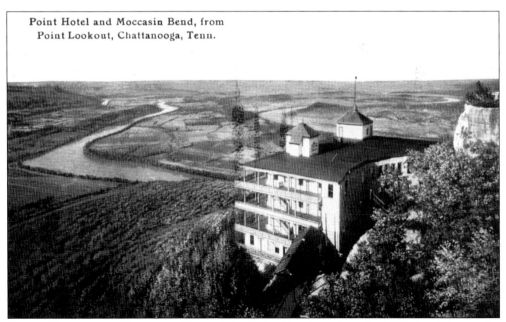

POINT HOTEL AND MOCCASIN BEND. The Point Hotel was built in 1888, just below Point Lookout, from the plans of McDaniel and Mighton of Chattanooga. A striking structure, it featured four levels of balconies that wrapped around the building, giving visitors a breathtaking view of the valley below. Rooms cost $2.50 to $4 per day, with bath included. The hotel was condemned and demolished in 1910. (Published by S.H. Kress.)

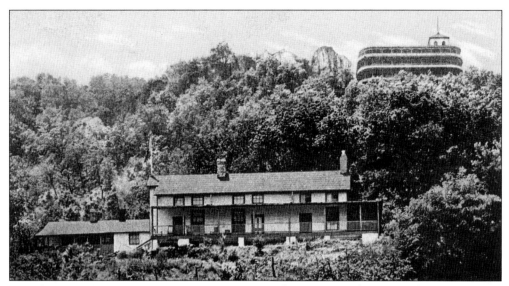

THE CRAVENS HOUSE AND POINT LOOKOUT. Looking up toward Point Lookout, we see the Point Hotel with its wrap-around balconies. Below, halfway down the mountain, is the Cravens House. Originally built in 1854 by Robert Cravens, an iron manufacturer, the house was destroyed during the Battle of Lookout Mountain. It was soon rebuilt. By 1956, the house was restored by the Association for Preservation of Tennessee Antiquities. (Published by Detroit Publishing Co.; postmarked 1906.)

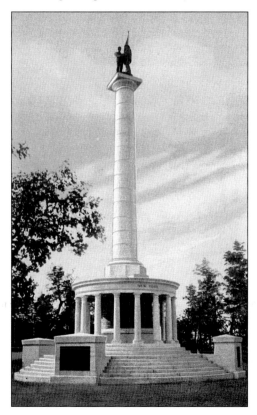

NEW YORK PEACE MONUMENT, LOOKOUT MOUNTAIN. This tall shaft of Massachusetts pink marble rises 95 feet and measures 50 feet in diameter at its base. Two bronze soldier figures, one Confederate and one Union, with an American flag between them, occupy the top of the pillar. The monument was erected in 1907. (Published by Detroit Publishing Co.)

GENERAL GRANT ON LOOKOUT MOUNTAIN. This postcard, published in the early 1900s, reproduces a historic photograph taken during the occupation of Lookout Mountain by Union troops. General Grant's victory here was one of the decisive battles of the war. (Published by D.R. Weill, Chattanooga.)

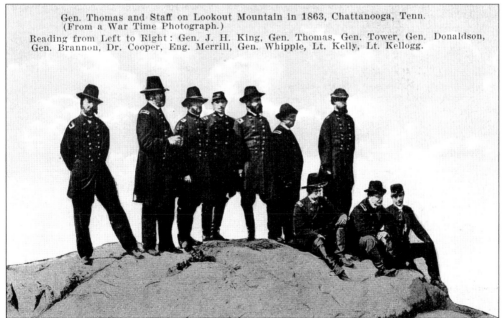

GENERAL THOMAS AND STAFF ON LOOKOUT MOUNTAIN IN 1863. Gen. George H. Thomas and his troops participated significantly in the battles around Chattanooga in 1863. Later he commanded troops at Atlanta and Nashville. Characterized by his insistence on detail and propriety, he was not a popular general, but he spent his entire life in the service. (Published by D.R. Weill, Chattanooga.)

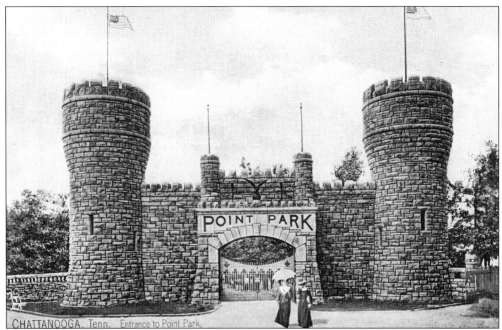

ENTRANCE TO POINT PARK. Point Park, part of the Chickamauga and National Military Park, is located at the extreme northern end of the crest and terminates at Lookout Point. It covers 17.5 acres of land. This entrance, built by the U.S. Army Corps of Engineers in 1905, is made of native pink sandstone, in a wall of the same material. The towers contain winding stairways of stone. (Published by Raphael Tuck and Sons, London; series 2587.)

WAR RELIC MUSEUM AT POINT PARK. Located near the entrance to Point Park is the War Relic Museum, which contains many remembrances of the Civil War. Among them are Grant's chair, Thomas's table, battle flags, and many other items. The museum is a tribute to Adolph S. Ochs (1858–1935), publisher of the *Chattanooga Times*. His leadership and financial contributions to preserve this area are responsible for its acquisition as a National Park. (Published by L.M. Mullenix, Lookout Mountain.)

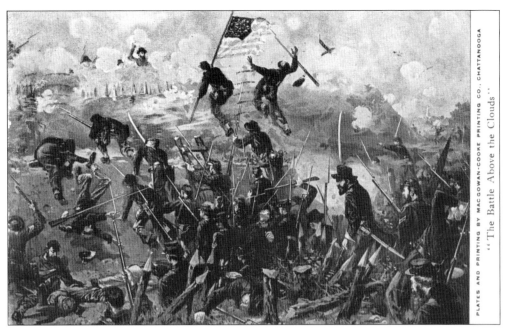

THE BATTLE ABOVE THE CLOUDS. Inside the entrance of the visitor's center at Point Park hangs this 13 by 30 foot painting by James Walker, who was actually present at the event. In 1863, Gen. Joseph Hooker commissioned the work, and Walker interviewed several Union generals to make sure his topography and placement of troops were correct. Hooker's relatives kept the painting until 1970, when they donated it to the park. (Published by Rollins and Harrison, Lookout Mountain.)

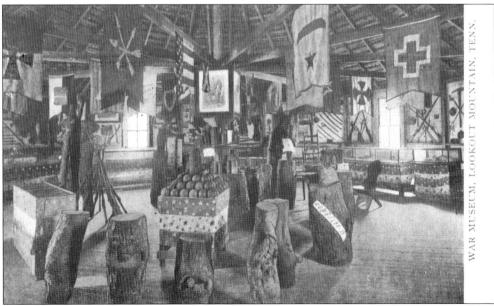

WAR MUSEUM, LOOKOUT MOUNTAIN. The interior of the War Museum is crowded with relics of all kinds from the war—flags, cannon balls, rifles, pictures, and insignia. The chair used in 1863 by General Grant at Orchard Knob and the table used by General Thomas at Chickamauga are also preserved here. (Published by MacGowan-Cooke, Chattanooga; postmarked 1910.)

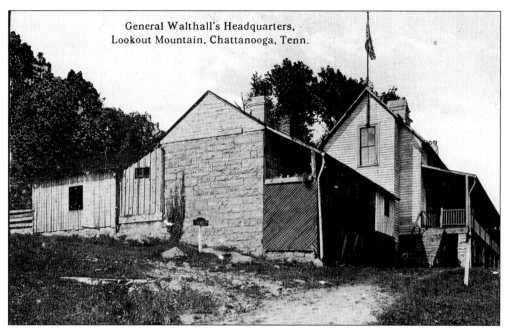

General Walthall's Headquarters,
Lookout Mountain, Chattanooga, Tenn.

GENERAL WALTHALL'S HEADQUARTERS. General Walthall's headquarters were located at Cravens House, halfway down the mountain from Point Lookout. This picture shows a side view. Much heavy fighting took place here on November 24, 1863, and the house was wrecked at the time. It was rebuilt on the same foundation. (Published by Read House Cigar Co., Chattanooga; postmarked 1914.)

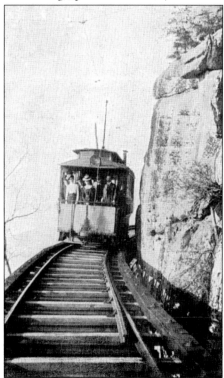

LOOKOUT MOUNTAIN, TENNESSEE. "ON THE HIGH TRESTLE." The Narrow Gauge Railroad extended from the Point Hotel around the west side of the mountain to Sunset Rock and the Natural Bridge. There were various inclines, railroads, and trolley lines to the top of Lookout Mountain built between 1880 and 1900. (Published by MacGowan-Cooke, Chattanooga.)

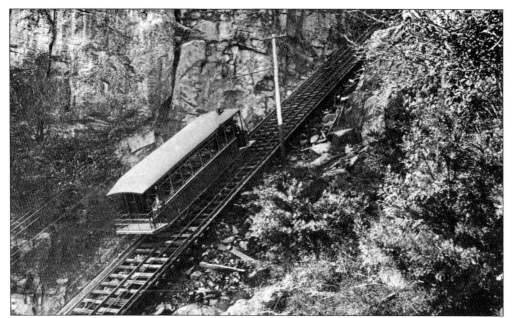

CABLE INCLINE UP LOOKOUT MOUNTAIN. The first incline was built in 1885 and the cars were open, with canvas sides. Each car could hold 35 passengers and the round-trip fare was 50¢. The second incline was built in 1895, and by 1899, the first incline was out of business. The new incline became the steepest passenger incline railway in the world, at one point climbing at a gradient of 72.7%. (Published by Detroit Publishing Co.)

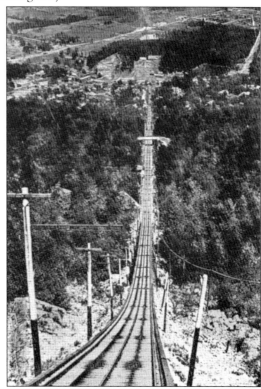

LOOKING DOWN THE INCLINE FROM TOP OF LOOKOUT MOUNTAIN. This scary vista has never intimidated tourists traveling either up or down the mountain. "America's most amazing mile" still attracts thousands of tourists every year. (Published by CCCC. Postmarked 1910.)

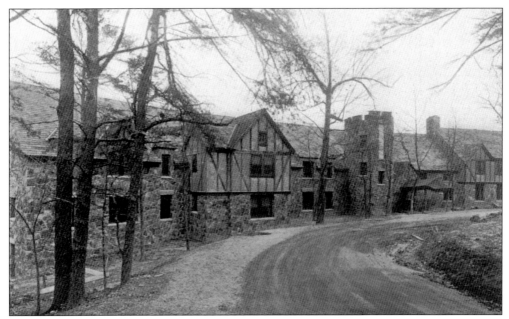

NORTH WING, FAIRYLAND CLUB, LOOKOUT MOUNTAIN. Fairyland, a 450-acre subdivision atop Lookout Mountain, was developed by Garnet Carter (Rock City developer) and a group of business associates. One hundred acres were set aside for landscape gardens and bridle paths. The Fairyland Club opened in June 1925. Mrs. Carter designed 10 cottages adjoining the club and called them Mother Goose Village. (Published by Lumitone Photo-Print, New York.)

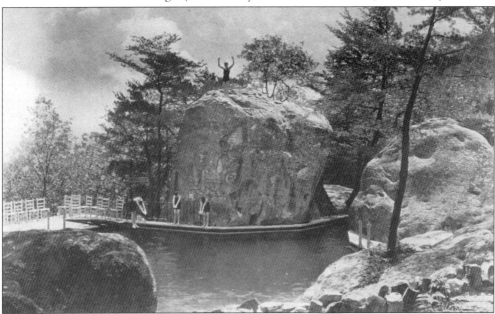

UNIQUE AND PICTURESQUE SWIMMING POOL, FAIRYLAND CLUB. In addition to the swimming pool, Fairyland Club offers tennis, horseback riding, and miniature golf; the latter was actually "invented" by Garnet Carter in 1930, when he devised a nine-hole "Tom Thumb" golf course in front of the club. The original miniature course was removed in 1958. (Published by Lumitone Photo-Print, New York.)

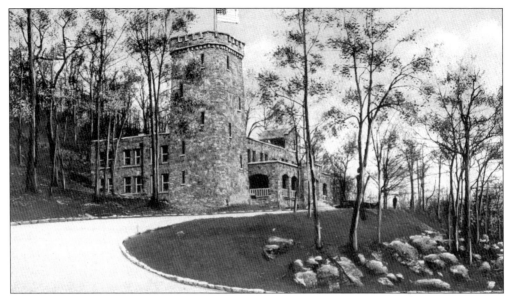

CAVERN CASTLE, ENTRANCE TO LOOKOUT MOUNTAIN CAVE. Cavern Castle is the entrance and administration building of Lookout Mountain Caves. There are two levels of caves. One, at the 420-foot level, shows evidence of early Native American occupancy. In 1928, an elevator shaft was sunk through the solid limestone, and a cave was discovered 260 feet below. The famous Ruby Falls, 145 feet high, is located here. (Published by T.H. Payne, Chattanooga.)

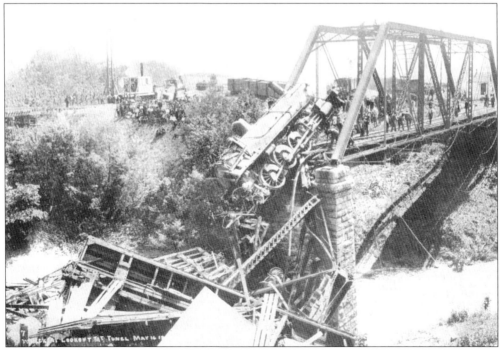

WRECK AT LOOKOUT MOUNTAIN TUNNEL, MAY 16, 1907. A local catastrophe, photographed almost immediately after it happened, is seen in this postcard view. The wreck was caused by a premature explosion of heavy blast on the Southern Railway. (Published by MacGowan–Cooke, Chattanooga; postmarked August 19, 1907.)

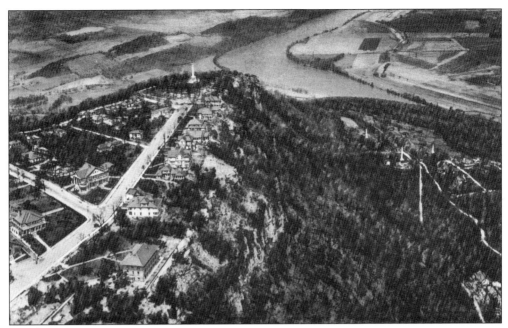

AERIAL VIEW OF THE TOWN OF LOOKOUT MOUNTAIN. Perched on top of the mountain, the town of Lookout Mountain extends south from Point Park to the Georgia state line. Limited by its topography, it contains many beautiful homes and monuments. The New York Peace Monument can be seen in the center. (Real Photo.)

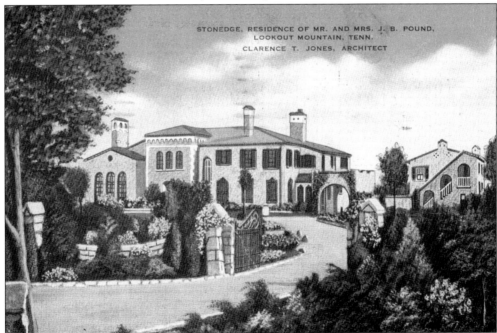

STONEDGE, RESIDENCE OF MR. AND MRS. J.B. POUND. One of the lovely homes on Lookout Mountain is the home of Mr. and Mrs. J.B. Pound. On the reverse side of the card, Mr. Pound is identified as president of the Hotel Patten in Chattanooga and several other hotels in various cities. (Published by E.C. Kropp, Milwaukee; postmarked 1945.)

"La Brisa," a Cottage Home. This is the summer home of Mr. I.C. Mansfield, located on Lookout Mountain. He calls the house "La Brisa, a cottage home amid the clouds." Mr. Mansfield is identified on the card as the manufacturer of "the famous Magic Food Poultry and Stock Specialties." From the 1920s, many Chattanoogans fled to the cleaner air and beautiful views of Lookout Mountain to build homes. (Published by MacGowan-Cooke, Chattanooga.)

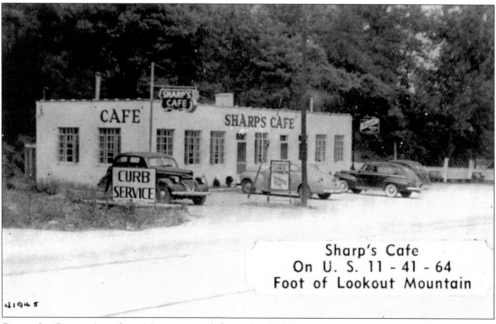

Sharp's Cafe. An advertising postcard from the 1930s invites us to come to Sharp's Cafe at the foot of Lookout Mountain "for the best—golden fried chicken—steaks. We open for breakfast at 6:30 a.m. Make this your eating place in Chattanooga." (Published by Kaeser and Blair, Cincinnati.)

ROCK CITY, LOOKOUT MOUNTAIN. In this early picture, two enthusiastic hikers sit on top of one of the many picturesque rock formations that later became known as Rock City. Not everyone would care to sit here, but many people did come to see. (Real Photo.)

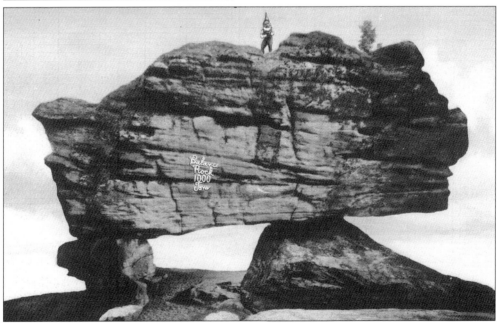

BALANCED ROCK, ROCK CITY GARDENS. Rock City Gardens has been a tremendously successful development for tourists. Rock formations such as this one have resulted in intriguing names like Pulpit Rock, Shelter Rock, Lovers Leap, Tortoise Shell Rock, and Fat Man's Squeeze. The developers have provided trails, overlooks, and gardens to thrill and entertain visitors. (Published by Curt Teich, Chicago.)

Seven
SIGNAL MOUNTAIN

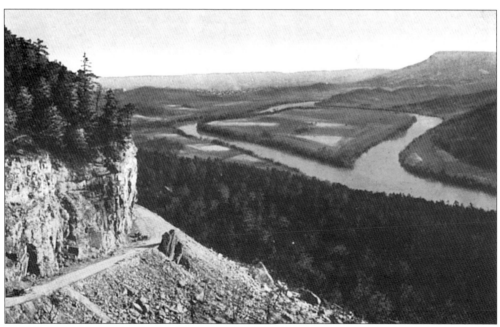

TENNESSEE RIVER FROM BOULEVARD AND AUTO ROAD, SIGNAL POINT. The view from Signal Point is wonderfully diversified. It includes the Tennessee River, Williams Island, Lookout Mountain, Missionary Ridge, and the city of Chattanooga. Tons of explosives made possible the path along the mountain for a boulevard and an electric car line. (Published by T.H. Payne, Chattanooga.)

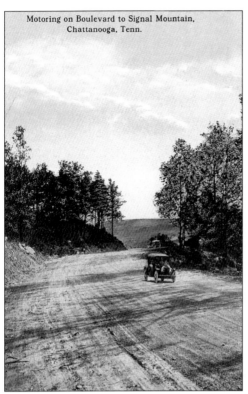

Motoring on Boulevard to Signal Mountain, Chattanooga, Tenn.

MOTORING ON BOULEVARD TO SIGNAL MOUNTAIN. Ascending Signal Mountain along the boulevard sculpted from the side of the mountain, we are privileged to view scenes equaled, some say, only by those on the Hudson or the Rhine. The road for automobiles runs parallel to that of electric cable cars going to the top of the 2,000-foot mountain. According to legend, Native Americans used the summit for signal fires that could be seen for 200 miles. (Published by T.H. Payne, Chattanooga; postmarked 1914.)

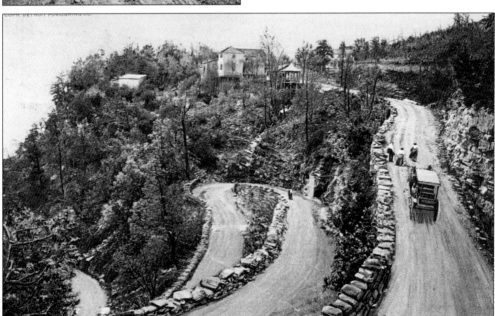

THE "W" ON WALDEN'S RIDGE. Walden's Ridge is the table land of the East Cumberland. Signal Mountain is its southeast end across the river, northwest from Chattanooga. The "W" road, a unique feat of engineering necessitated by the topography of the mountain, was built in 1893. This early postcard shows the road before modern improvements were made. (Published by Detroit Publishing Co.; postmarked 1912.)

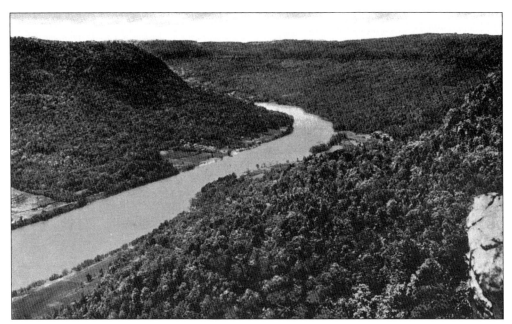

THE GRAND CANYON OF THE TENNESSEE. From the boulevard to Signal Mountain, one can see "The Grand Canyon of the Tennessee," compared favorably to scenes in the Bavarian Alps. The sides of this canyon tower 1,000 feet above the river for some 20 miles. Because the river here is only 100 yards wide, it has always been extremely rough and dangerous. In earlier days, this region was called "The Narrows" and "The Suck"; it became safely navigable only when Hales Bar Dam was constructed in 1913. (Published by Andrews Printery, Chattanooga.)

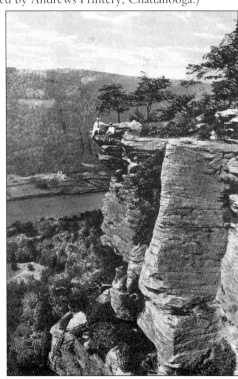

BRADY'S POINT, SIGNAL MOUNTAIN. During the Civil War, the Federals advancing from the north used Signal Mountain as a point from which signals were sent to troops south of the mountain. Brady's Point is one such notable location. (Published by D.R. Weill, Chattanooga.)

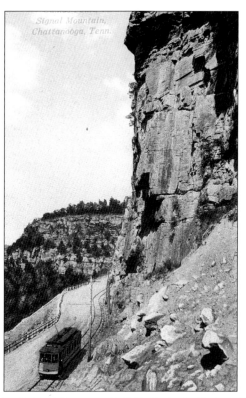

JAMES POINT, SIGNAL MOUNTAIN. At this location, a metal plaque is placed in a large boulder in honor of Charles E. James, the realtor who developed the area. The boulevard and electric car line led to the Signal Mountain Inn at the top. (Published by Read House Cigar Co., Chattanooga.)

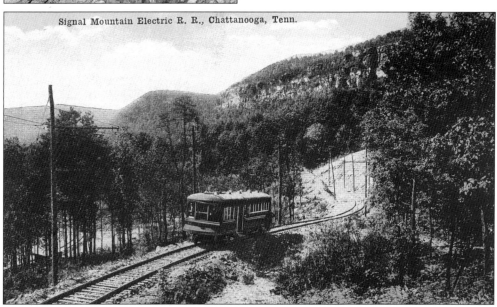

SIGNAL MOUNTAIN ELECTRIC R.R. Two modes of transportation led to the top of Signal Mountain. Tourists wishing to partake in "the health–giving properties" of the mountain air and the amusements available at "one of the finest hotel resorts in the South" could drive by automobile, or travel by electric trolley to "the magnificent fireproof hotel" at the top. The trolley travel time was 40 minutes; by car, it would have taken 20 minutes. (Published by Read House Cigar Co., Chattanooga.)

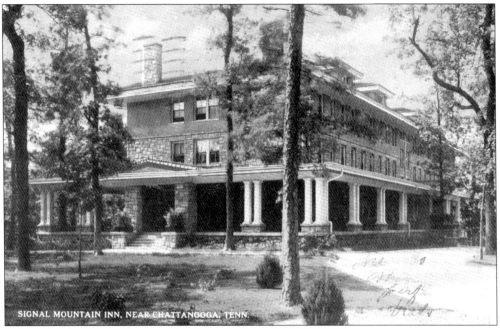

SIGNAL MOUNTAIN INN, NEAR CHATTANOOGA, TENN.

SIGNAL MOUNTAIN INN. Built of pink sandstone, this splendid hotel stood at the summit of the mountain. It advertised its "cool, healthful air and fine water," a golf course, and easy accessibility. It was bought in 1938 by the Alexian Brothers, who converted it into an assisted-living home. (Published by Read House Cigar Co., Chattanooga; postmarked 1913.)

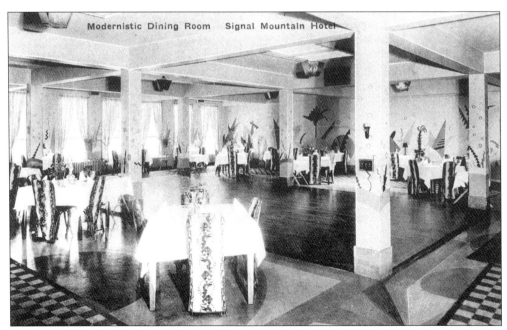

Modernistic Dining Room Signal Mountain Hotel

MODERNISTIC DINING ROOM, SIGNAL MOUNTAIN HOTEL. Exhibiting a rather sparse decor, the Signal Mountain Hotel dining room also seems rather small. It has a dance floor in the center of the room that gives it a nightclub ambiance. (Published by Albertype, Brooklyn.)

115

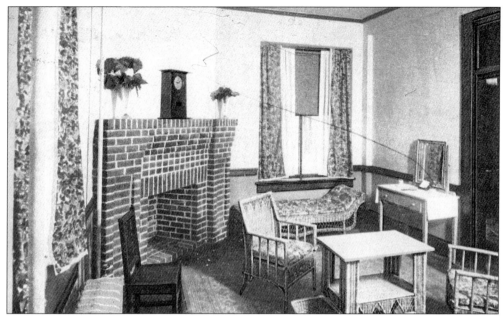

LADIES REST ROOM, SIGNAL MOUNTAIN INN. In this interior view of Signal Mountain Inn, the ladies' rest room reveals rather plain accoutrements. The chairs, couch, vanity table, and curtains seem efficiently thrifty in appearance. Even the fireplace is bare. (Published by Detroit Publishing Co.; postmarked 1916.)

ROOF GARDEN, SIGNAL MOUNTAIN INN. Evidently one of a series of postcards showing various parts of the inn, this view of the roof garden is strangely bare, as though tables had just been removed. The Japanese lanterns indicate a party atmosphere; perhaps the party had just concluded. (Published by Detroit Publishing Co.; postmarked 1916.)

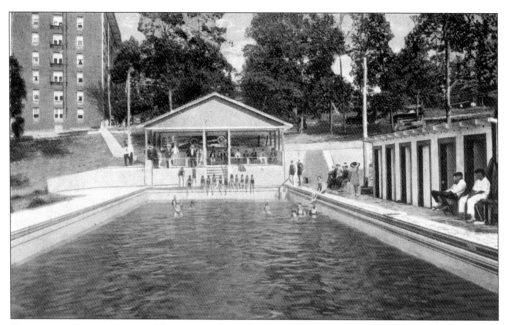

SWIMMING POOL, SIGNAL MOUNTAIN INN. A scene from the early 1930s shows the inn pool, measuring 80 feet by 30 feet, with water "absolutely clean and pure, being filtered and sterilized by the latest sanitary process." The ladies' bathhouse is seen on the right; two attendants sit in front. (Published by E.C. Kropp, Milwaukee.)

LINGER LONGER COTTAGE TOURIST HOME SIGNAL MOUNTAIN, TENN.
Via CHATTANOOGA

Elevation 2,000 feet, overlooking historic Chattanooga Valley. Paved road to our front gate.

ROOMS $1.00
MEALS 50c **Open All Year : Home Cooking : All Modern** VACATIONISTS, $10.50, $12.50, $14.00 per week

Telephone: Dial 8-2511, or write D. R. WALKER, SIGNAL MOUNTAIN, TENNESSEE

LINGER LONGER COTTAGE, SIGNAL MOUNTAIN. A typical advertising postcard from the 1930s shows a tourist haven less endowed than the big inn. This view of Linger Longer Cottage shows a couple playing golf (left) and another couple playing shuffleboard (right). There's plenty of shade, too. (No publication data available.)

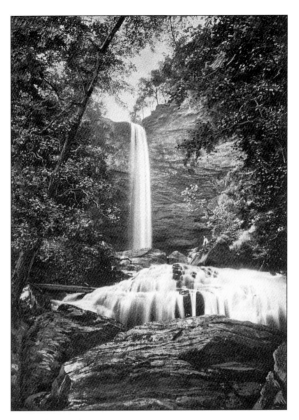

FALLING WATER, WALDEN'S RIDGE. This scene has become famous among all the beauties of Walden's Ridge. General Sherman expressed his awe when he viewed it: "In the midst of carnage and noise, I could not help stopping to admire its sublimity." (Published by Raphael Tuck and Sons, London; series 2402.)

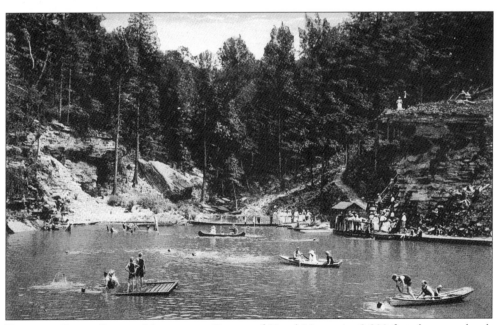

RAINBOW LAKE, SIGNAL MOUNTAIN. On top of Signal Mountain, 2,200 feet above sea level, Rainbow Lake was within easy walking distance of the Signal Mountain Hotel. It was popular with both swimmers and boating enthusiasts. (Published by J.H. Dootson, Signal Mountain.)

Eight

POTPOURRI

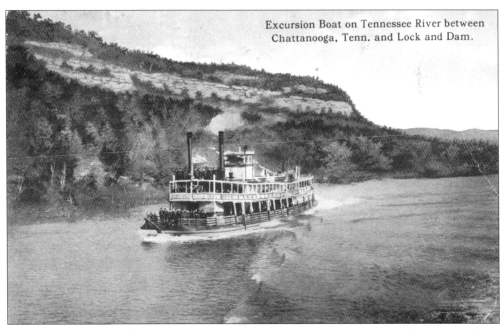

EXCURSION BOAT ON TENNESSEE RIVER BETWEEN CHATTANOOGA AND LOCK AND DAM.
Another way to see the scenic beauties of river and mountain has been by excursion boat. This trip has been an easy one since Hales Bar Dam was built in 1913. (Published by Read House Cigar Co., Chattanooga; postmarked 1915.)

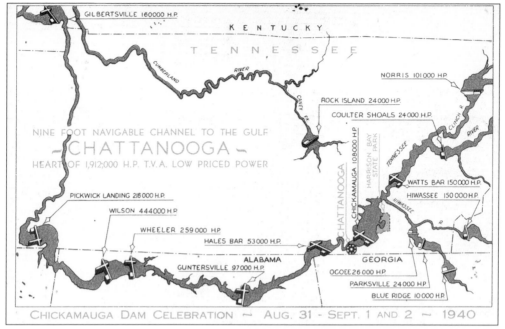

NINE-FOOT NAVIGABLE CHANNEL TO THE GULF. Published for the Chickamauga Dam Celebration on August 31 and September 1–2, 1940, this map shows clearly "where the dams are." Note that Chattanooga lies between two dams—Hales Bar on her left side (1913) and Chickamauga on her right (1940). (Published by Chickamauga Dam Committee, 1940.)

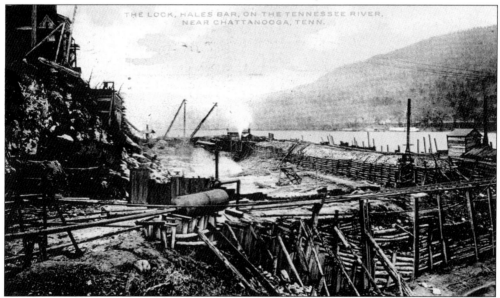

THE LOCK, HALES BAR, ON THE TENNESSEE RIVER. Shown here under construction, Hales Bar is located 33 miles downstream from Chattanooga (13 miles by land); it is 1,200 feet long with masonry 50 feet thick. According to 1906 expectations, the turbines in the base were to supply enough horsepower to make it second only to Niagara Falls, the largest water power plant in the world. The lock had a lift of 40 feet. This lock and dam eliminated the dangerous suck in the Narrows which caused many accidents. (No publication data available.; postmarked 1909.)

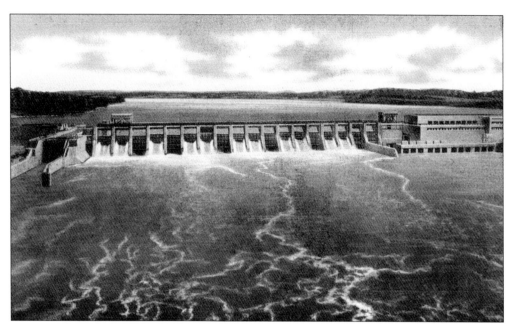

CHICKAMAUGA DAM. Located just above Chattanooga on the Tennessee River, Chickamauga Dam was completed by the Tennessee Valley Authority on January 15, 1940. It is 129 feet high and 5,794 feet long, with a reservoir area of 37,200 acres, extending 59 miles upstream. It cost $32 million to build. (Published by W.M. Cline, Chattanooga.)

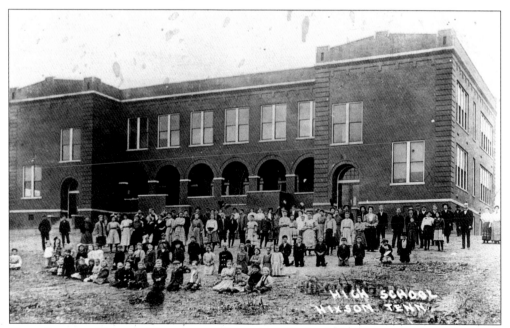

HIGH SCHOOL, HIXSON, TENNESSEE. Hixson is a suburb of Chattanooga on the north side of the river. In this 1914 view, students pose for their portrait. The kneeling children in front are obviously not of high school age; evidently, elementary ages were included as well. Two teachers (right) are dressed in the "uniform" of the period—skirt and shirtwaist. (Real Photo; postmarked 1914.)

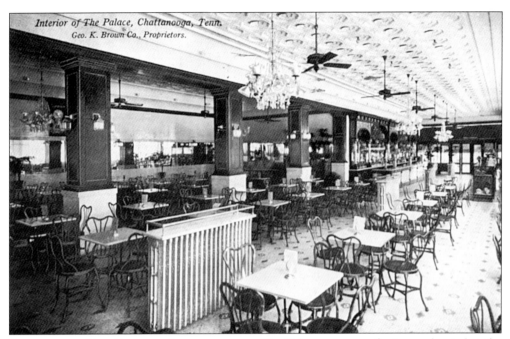

INTERIOR OF THE PALACE, CHATTANOOGA. The Palace was a confectionery located at the corner of Market and Seventh Streets in Chattanooga. It is interesting to note how small and numerous the tables are; there is a bar for ice cream treats near the doors in the distance and a glass display counter. The radiators are free-standing, in a row from the front to the back of the establishment. (No publication data available; postmarked 1913.)

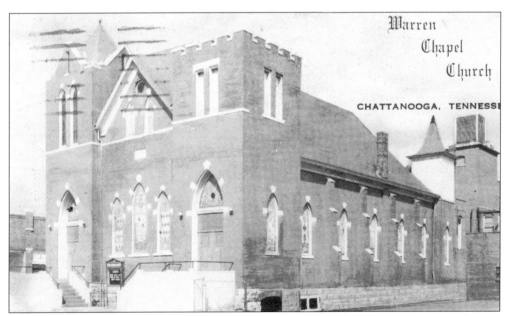

WARREN CHAPEL CHURCH. This A.M.E. church was built in 1897 at the corner of Chestnut and Sixth Streets. Services were held in the stone basement for a number of years until the building was completed. (No publication data available.)

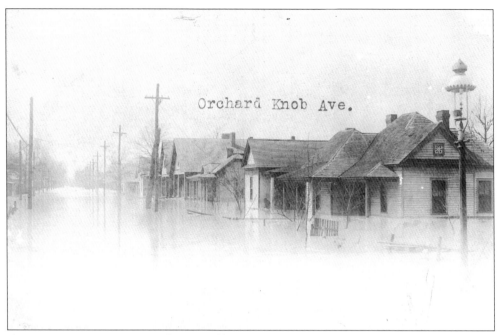

ORCHARD KNOB AVENUE. This view illustrates the extent of the 1917 flood in the Orchard Knob community. The comment on the back of the card says: "Every street in Oak Grove was under water . . . it reached the first floor of the school house." (Real Photo.)

UNIVERSITY OF CHATTANOOGA. Pennant postcards have often been sent from colleges. A student wrote his message on the front of this card, since postal regulations allowed only the name and address of the addressee on the back. The sender was not careful about spelling. Translated, he writes as follows: "I am studying law now and doing fine. I will write you a letter. Are you still studying? Let me know. From your friend, Francis B.H." (Published by Thomas J. Beckman, Philadelphia; postmarked 1909.)

Three Things a Savings Account Will Do. Institutions such as the First National Bank have sent postcards to potential customers ever since the postcard was invented. An attractive picture illustrates the motto at the top: "The Longest Journey Starts with One Step." (Published by G.B. Co., Joliet, Illinois; postmarked 1932.)

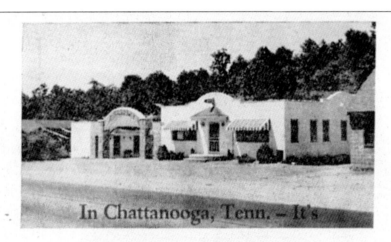

Burkhardt's Strictly Modern Tourist Court and Dining Room. This advertising postcard pictures a fairly modest tourist court, designed in a popular style of the 1930s. It was a bonus if a dining room was a part of the establishment. (No publication data available.)

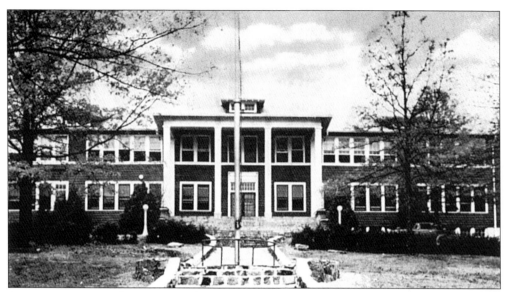

ADMINISTRATION BUILDING, SOUTHERN MISSIONARY COLLEGE, COLLEGEDALE, TENNESSEE. A few miles to the east of Chattanooga lies Collegedale, home of Southern Missionary College. Founded in 1892 by Seventh-Day Adventists as Southern Junior College, it went through several name changes through the years. In 1944, it achieved senior college status. In 1982, the name changed again to Southern College of Seventh-Day Adventists. (Published by Eagle Post Card View Co., New York.)

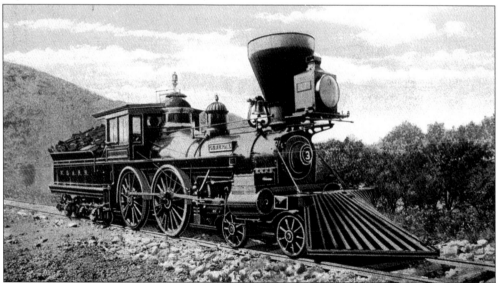

THE *GENERAL*, USED BY ANDREWS RAIDERS. This famous engine was stolen by Federal raiders at Big Shanty, Georgia, in April 1862 and was recaptured after an exciting chase. Capt. James Andrews and a group of Federals in disguise had attempted to steal the engine, progress northward along the railway, and burn the bridges in order to cut off the Confederates from their base of supply. Within a week, the *General* was retrieved, and Andrews and his companions were captured and later executed. The *General* was on exhibit for years at Union Depot in Chattanooga; in 1972, it was returned to Kennesaw, Georgia, to be displayed at the Civil War Museum. (Published by T.H. Payne, Chattanooga.)

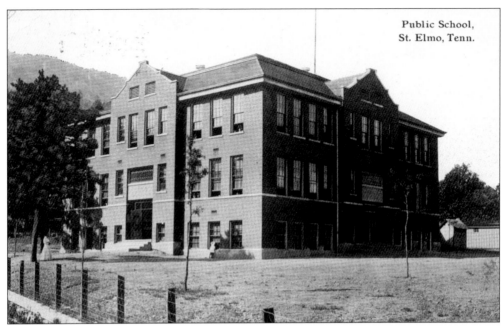

Public School,
St. Elmo, Tenn.

PUBLIC SCHOOL, ST. ELMO, TENNESSEE. St. Elmo is the section of Chattanooga just south and across the river from the tip of Moccasin Bend. It is from St. Elmo Avenue that one boards the incline railway to the top of Lookout Mountain. In 1911, the public school looked like this. (No publication data available; postmarked 1911.)

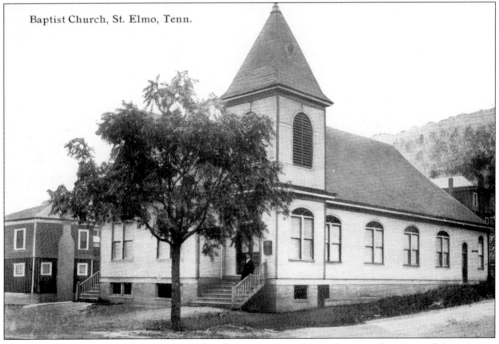

Baptist Church, St. Elmo, Tenn.

BAPTIST CHURCH, ST. ELMO, TN. St. Elmo was a modest suburb at the time of the picture (c. 1912), and the Baptist church reflects this quality. The frame-structured building is designed with just a hint of Romanesque in the rounded windows. (No publication data available.)

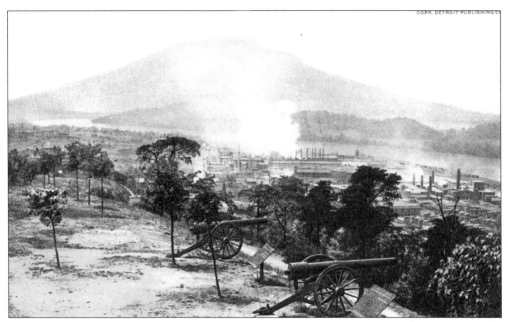

MANUFACTURING DISTRICT FROM CAMERON HILL, CHATTANOOGA. Looking down on the industrialized district of Chattanooga from Cameron Hill are two cannon reminiscent of the battles of the 1860s. Looking up, one always sees Lookout Mountain. (Published by Detroit Publishing Co.)

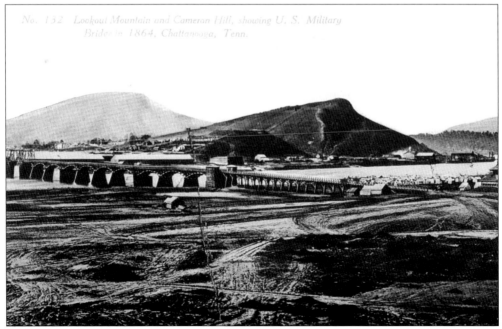

LOOKOUT MOUNTAIN AND CAMERON HILL, 1864. Looking from the north side of the Tennessee River is a view of Cameron Hill. This military bridge was built by the Union Army in 1863; it was a wooden structure with a dozen piers made of wooden cribs and filled with stone and dirt. It was washed away in the flood of March 11, 1867.

127

BIBLIOGRAPHY

Bowman, John S., ed. *The Civil War Almanac*. New York: World Almanac Publications, 1983.

Catton, Bruce. *Never Call Retreat, Vol. 3, The Centennial History of the Civil War*. New York: Doubleday, 1965.

Chattanooga City Directories, 1878–79, 1903, 1929.

Chattanooga Yesterday and Today. 4 vols. Chattanooga: Hiener Printing Co., 1951.

Federal Writers' Project of the Work Projects Administration for the State of Tennessee. *Tennessee: A Guide to the State*. New York: Viking Press, 1939.

Govan, Gilbert, and James W. Livingood. *The Chattanooga Country, 1540–1976*. 3rd edition. Knoxville: University of Tennessee Press, 1977.

McGuffey, Charles D., ed. *Standard History of Chattanooga, Tennessee*. Knoxville: Crew and Dorey, 1911.

Patrick, James. *Architecture in Tennessee, 1768–1897*. Knoxville: University of Tennessee Press, 1981.

Sakowski, Carolyn. *Touring the East Tennessee Backroads*. Winston-Salem: John F. Blair, 1993.

Wade, Elizabeth K. *History of Chattanooga High School*. Chattanooga: Adams Lithographing Co., 1974.

Webster, Susie McCarver. *Historic City—Chattanooga*. Chattanooga: Susie M. Webster, 1915.

West, Carroll van. *Tennessee's Historic Landscapes: A Traveler's Guide*. Knoxville: University of Tennessee Press, 1995.